MW00628134

IMAGES
of America

WHARTON

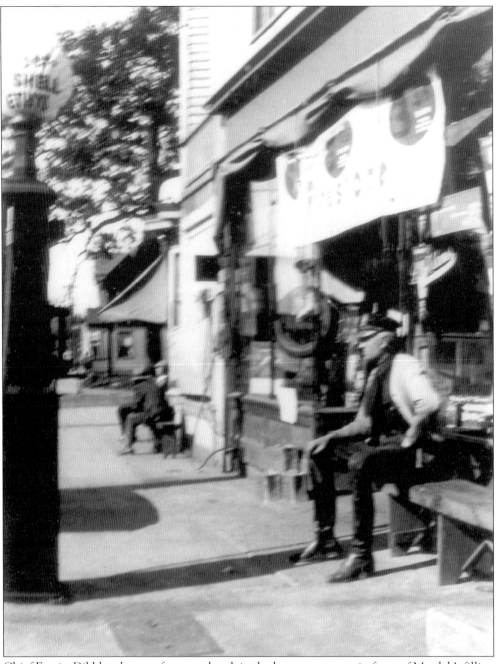

Chief Everitt Dibble takes an afternoon break in the hot summer sun in front of Mordak's filling station on Main Street *c.* the early 1940s.

IMAGES
of America

WHARTON

Charlotte Kelly and Alan Rowe Kelly

ARCADIA

First published 2004

Published by Arcadia Publishing,
an imprint of Tempus Publishing Inc.
Portsmouth NH, Charleston SC, Chicago,
San Francisco

Printed in Great Britain

Library of Congress Catalog Card Number: 2004101179

For all general information, contact Arcadia Publishing:
Telephone 843-853-2070
Fax 843-853-0044
E-mail sales@arcadiapublishing.com
For customer service and orders:
Toll-free 1-888-313-2665

Visit us on the Internet at www.arcadiapublishing.com

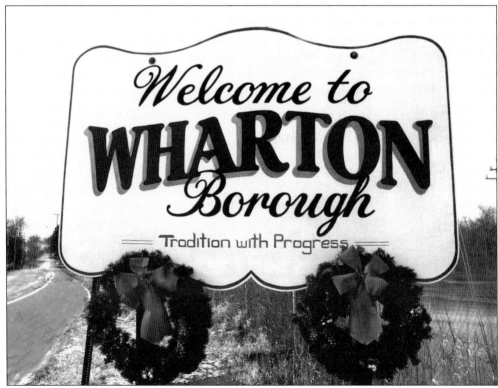

This sign says it all: "Welcome to Wharton."

CONTENTS

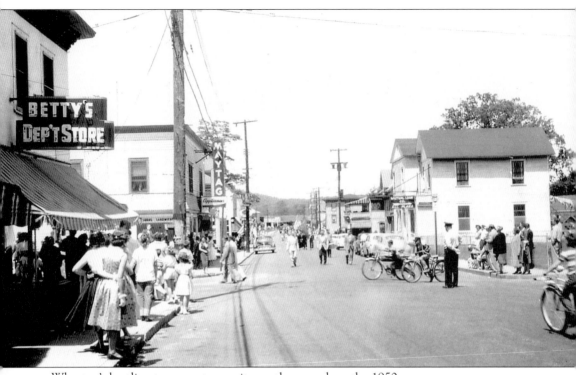

Wharton's bustling town center awaits another parade *c.* the 1950s.

INTRODUCTION

Remember when around the corner seemed far away and when going into town seemed like going somewhere? I never thought of Wharton as a hotbed of history and industry, from which its original roots had stemmed. For a time, it was simply the town where I was born and raised. It was where my parents were raised, and their parents before them, and so on. Born in the late 1950s, I am the last of a generation to be brought up in a town where everyone knew everyone. We were safe and untouched by the outside world. Wharton and its people were built to stand on their own, and I believed that all towns were just like ours.

My memories of Wharton seem old-fashioned now—buying flavored wax lips and mustaches at Betty's for a nickel, ice-cream cones topped with sherbet from Prandatos if we behaved, and off to Rocky's for baseball cards and bubble gum and then some Kool-Aid powder sticks from Helen's Diner at the corner of Main and East Dewey Avenue. If you had a buck in your pocket, you were rich. I would sit in the backseat of my dad's Bel Air, and he would beep his car horn when passing Mordak's curbside gas station on Main Street. Little League and peewee baseball was the highlight at Wharton Park. Sleigh riding down High Street and skating on Washington Pond became winter's daily routine. Every hot summer day, there was swimming in the Morris Canal, or a sleepy afternoon spent fishing on the pond before taking a dive off Second Rock. Every July, the firemen's annual carnival was held at the old Schaefer Field. The St. Mary's yearly picnic in the grove followed before Labor Day. Neighborhood kickball at sunset on Ross Street was always accompanied by a twilight game of wolf. My friends and I ran shrieking with laughter through the neighborhood. No one really seemed to mind.

I had no idea, until I started research for this book, how much my hometown of Wharton contributed to the growth and expansion of the entire state of New Jersey. Like all of America's small towns, Wharton suffered through the Depression, two world wars, and political and civil unrest. Wharton gave birth to some of Hollywood's first silent train robberies as well as the very first onscreen Superman, Kirk Allyn. Yet with all the changes and demands brought on by the 21st century, it is a town still intact. Industry, technology, and land development may have carved their way onto Wharton's main streets, but the town has preserved much of its original landscape. When comparing old and new photographs of the town today, its peaceful appearance has barely changed in 100 years. Many of the descendants of our original settlers live here still, on roads bearing their family names.

—Alan Rowe Kelly

I was born in Wharton in a house on Huff Street and lived most of my life here (college notwithstanding), working as a flight attendant for Eastern Airlines. Both my parents are from Wharton too. I remember my mother's parents telling stories of emigrating from Hungary and establishing themselves in their new country. On the other hand, my father told tales of his grandfather, a Lenape Indian from Lake Denmark, and his grandmother, a Dutch girl named Walton, who is now buried in the Walton Yard at Picatinny Arsenal.

I had my first great experience at five years old in first grade at Potter School when the Hercules Powder Explosion came roaring over the hill on September 11, 1940. Pearl Harbor was attacked the following year, followed by rations of gas, meat, sugar, and butter, which was margarine. Remember the orange capsules you broke open and mixed in to make it look like butter? We collected tin foil, cans, rubber, iron, and 10¢ stamps to go toward war bonds; we collected anything of use for the war effort. I will never forget relatives and friends going off to war; some came home, and some did not. On the day the war was declared over, my family and I went to a gathering at Hurd Park in Dover, and I found a sailor hat on the ground. I still have it today.

Living on Langdon Avenue was splendid. We rode in the sleigh down "the hill," as we called it, a dead end until the 1950s, and skated on Sin Pond (now the post office and parking lot), or, once we got older, at Coon Pond past the woods off Langdon. Days were filled with horseback riding and baseball games in Huff Field, which is now a mall and the Route 80 overpass. Every day around 4:30 p.m., I walked down the road to meet my father and grandfather coming home from Picatinny Arsenal, which in those days employed a large number of borough residents.

I walked to school along Washington Pond and amongst the leaves just to hear the sound and see the changing seasonal colors along the water. School was a wonderful experience for me. I remember basketball games in our infamous gym, hanging out at the Sugar Bowl, or Helen's Diner, and stopping in at Maggie Kaiser's store on the way home. I can still see the boys running next door to Rocky's between classes—not that they were supposed to.

Sunday afternoons were filled with football games, bonfires, and watching the Wharton Rockets while the Parent-Teacher Association (PTA) sold hot dogs and soda at the stands.

In town, most of the older men gathered at Flartey's, or Danielson's Paper Store, and the fire department. Their favorite place, however, was Louis Concialdi's Pharmacy. What a wonderful man Louis Concialdi was, so kind and always giving.

I left Wharton to attend college in Virginia and then went off to Florida for flight attendant school and duty in New Orleans. I married a young local man from St. Mary's—the first state trooper from Wharton. I have three wonderful sons, two state troopers, and one writer–film director. The borough of Wharton has produced 10 state troopers—a great accomplishment.

I enjoy my life here in Wharton, volunteering, seeing folks who have never left and the young newcomers with families coming in. My hope is that the borough's future will stay small and always family friendly.

—Charlotte Kelly
President of Wharton Historical Society

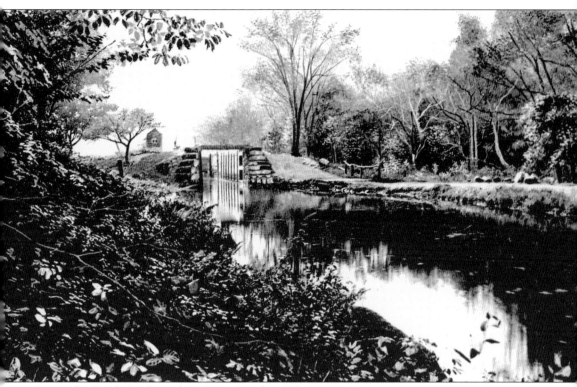

Pictured is Burd's Lock on the Morris Canal in Wharton *c.* 1910.

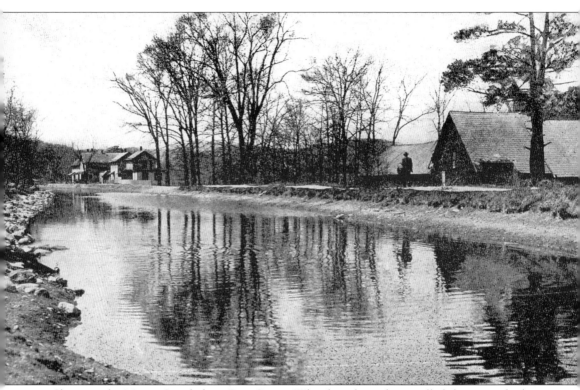

Shown is the Morris Canal along Pine Street. What has always been called the towpath along the Morris Canal still exists and is known as the "best watered" section of the Morris Canal today. It is still possible to take a peaceful stroll along the canal all the way up to the remains of Burd's Lock and the tender's house. The park and public works garage stands along West Central Avenue at the bottom of the canal abutment, and remains of the railway and its stone walls still frame the south side of the canal.

One

EARLY DAYS IN
NORTHWEST NEW JERSEY

At the time of its discovery by early settlers, the area now known as Morris County was inhabited by the Delaware and Algonquin Indians, or, as they termed themselves, the Lenni Lenapes, "the original people" or "unmixed people." They had traveled eastward from the western part of the continent, where they resided for many centuries, with the Mengwe and Iroquois tribes. By the 15th century, the Lenapes occupied the entire northern region of what would eventually be called New Jersey. Similar in government to the Iroquois, they divided into totemic tribes known as the Wapanachki, the Unami, the Unalachta, and the Minsi. Most popular to Wharton area were the smaller tribes from which various towns were named: Whippanongs, Pomptons, Rockawocks, Minisinks, Musconetcongs, and Hopatcongs.

The greater portion of this ancient region is underlain by rocks that belong to the oldest geological formation known in the world, azoic, meaning "absence of life," and includes all the syenites, gneiss, granite rocks, crystalline limestone, and, most importantly, magnetic iron ore. The presence of iron ore in northern New Jersey was well known to the Indians. They even named a portion of this locality Suckasuna, or Sook-Soona, which means "black stone" or "heavy stone." (This terrain would later become Succasunna, Wharton's neighbor.)

The histories of the anthracite and iron-ore industry of Morris County reaches back almost to its first settlement. By the mid-16th century, the early Dutch and English colonists began buying off the land from the Lenapes and their numerous tribes for the mere price of blankets, rifles, silver, and rum.

The purchasing of Morris County was completed in 1714, and by 1740, its many township boundaries had been created. In the 10 years that followed, the once flourishing Lenni Lenape populace disappeared from the area.

As early as 1710, the first known forge within the present bounds of the county was erected in Whippany on what was then called the Whippanong River. In 1722, the town of Dover built its very first forge. Great advances were being made in the manufacturing of iron, and many private forges and furnaces were sprouting up throughout the county between 1748 and 1750.

In 1795, Charles Hoff Jr., former manager of the Hibernia Furnace, and his brother-in-law Joseph DeCamp broke ground on the west branch of the Rockaway River just before its east branch junction to build the Washington Forge. Washington Forge marked the beginnings of what is known today as Wharton. Charles Hoff sold his half of the business to Joseph Hurd in 1808, and DeCamp heirs sold theirs to Joseph Dickenson, who owned the whole in 1828.

From the production of cannons and iron cannonballs during the American Revolution to the War of 1812 and the Civil War, iron was quickly becoming the economic backbone of

Morris County. With a land so abundant in mineral product and natural resources, the demand for charcoal, anthracite, and ore, although still comparatively limited, was also growing.

Soon, there was a surplus of forges and furnaces, with many falling into disuse principally due to the lack of cheap transport. So in 1822, a man named George P. McCulloch of Morristown first conceived the idea for building the Morris Canal while on a fishing excursion to Lake Hopatcong, then known as Great Pond. McCulloch attempted to interest the state legislature in a project that would build a canal route for shipping cargo across the western and eastern portion of northern New Jersey. However, the state rejected the high cost estimate and left it to private enterprises. So, by December 31, 1824, the independent Morris Canal and Banking Company was formed with capital of $1 million. After much debate, outside criticism, and costly experiments, the 90-mile canal was completed from Easton, Pennsylvania, to Newark in August 1831 at the cost of $2 million, and its first trip was conducted on November 4, 1831. With 12 planes and 17 locks, the canal allowed full passage from the Delaware River to the tidewaters of the Passaic in less than five days. Continuation of the canal to Jersey City was completed in 1836.

Now, other forms of major transport were needed. Throughout the 1830s and 1840s, the common saying was "If the canal comes, can the railroad be far behind?" The legislature of New Jersey, seeing the prior error of their ways by not backing the Morris Canal, incorporated the Morris and Essex Railroad on January 29, 1835. The rate for freight was limited to 6¢ per ton for each mile as well as 6¢ per mile for each passenger. Progress in Morris County was moving ahead.

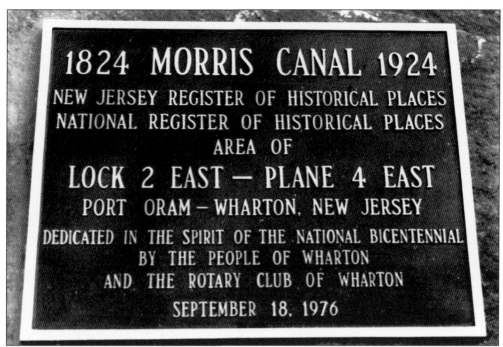

Pictured is the Morris Canal plaque.

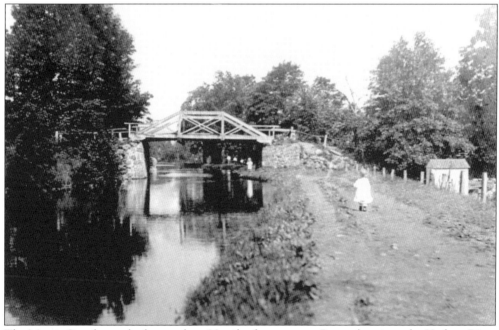

The Morris Canal stretched more than 90 miles from eastern Pennsylvania to the Hudson River of Jersey City. Shown is Central Avenue along the canal. Today, signposts at various city ports across the northern end of the state mark landmarks of the once active thoroughfare. Wharton still preserves one of the longest stretches of the existing Morris Canal.

Robert F. Oram came to the United States from the tin mines of Cornwall, England, in 1845. Three years later, he began mining the hard rock of New Jersey, taking charge of the Swedes Mine in Dover and the Mount Pleasant Mine. The following year, he began supervising the Orchard Mine. Later, the Mellon Mine and Beach Glen properties were also purchased. With life as an ore-shipping port on the Morris Canal well under way, the area once known as Irondale Docks became Port Oram.

Two

THE BIRTH OF PORT ORAM

In 1845, 20-year-old Robert F. Oram immigrated to the United States from the tin mines of Cornwall, England, to first settle in Pottsville of Schuykill County, Pennsylvania. With his brother, Thomas Oram, he engaged in the mining and shipping of coal to Philadelphia. At the time, coal mining was in its infancy and catching on quickly as a lucrative trade. Robert Oram married Hannah Williams of Wales in 1847, and the Oram brothers moved to mine the hard rock of New Jersey in 1848, when they were offered the charge of the Swedes Mine in Dover. Robert Oram also took charge of the prominent Mount Pleasant Mine on August 16, 1848. In 1849, he expanded his operation with the purchase of John Hance's log cabin and the Burrill farm near the Washington Forge to begin supervising the Orchard Mine the following year. The Mellon Mine and Beach Glen properties were also purchased, and life as an ore-shipping port on the Morris Canal was now well under way. This area at the time was known as Irondale Docks.

Prior to 1850, the ore mined in the county was manufactured largely for county use only. The charcoal and anthracite furnaces were at their greatest activity for the first half of the century, but after 1850 the demand for ore in other counties of the state and to other states began to assume importance. That demand only increased, and the mining of ore became the principal department of the iron industry in the country. The "iron rush" was now off and running.

By 1858, the beginnings of the borough of Port Oram were being set into motion when Robert Oram purchased the surrounding lands and began property development. He built four houses in 1859 and, with John Hance, built the Port Oram Store House. The storekeeping business began in 1860 in association with John Hill and William G. Lathrop of Boonton. Following Hill's retirement that same year, the firm of Oram, Hance, and Company was born. Port Oram did not grow much until after the Civil War, but from the beginning, a large business was conducted from the company store.

The locality now covering an area of two and a quarter square miles west of Dover was divided into settlements called Irondale, Luxemburg, Marysville, Mount Pleasant, and Port Oram, the largest member of the group. Port Oram did not yet exist as a place apart; it was merely a segment of an industrial expansion. Although it was made up of simply mine camps and housings for the blast furnace and mill workers, Port Oram was still the best place in Morris County adapted for the manufacturing of iron, especially as far as railroad and canal facilities were concerned. The Morris Canal and the Morris and Essex Railroad passed directly through its center, and the Mount Hope and Chester railway branches also terminated here. The High Bridge branch of the Central Railroad of New Jersey and the Dover and Rockaway Road, connecting with the Hibernia Railroad, made Port Oram their junction as well. In 1860, Port Oram had no choice but to build its own freight depot and add a railway extension westward to Hackettstown.

From 1864 to 1868, more than 40 buildings were erected, and the population grew from 4 families to 64 families, making nearly 400 persons. The first schoolhouse was built in 1867 and presided over by Henry Allen as teacher, followed by two brief terms of a Mr. Pryer and a Mr. Mase. Erastus E. Potter was invited to Port Oram in 1871 on a month's trial. He stayed and later became principal, elevating the literary character of the place. On April 9, 1867, residents John Hance, Conrad and Adolph Poppenhusen, John C. Jardine, George Viator, Elias M. White, James H. Neighbour, and Alexander Elliot incorporated the New Jersey Iron Mining Company. Competition was fierce. So as not to be outdone, Robert F. Oram, John Cooper Lord, William G. Lathrop, C. D. Schubarth, W. H. Talcott, Henry Day, Theodore F. Randolph, and the savvy James H. Neighbour incorporated as the Port Oram Mining Company on

March 31, 1868. They constructed the largest furnace in the area and produced 150,000 tons yearly. A depression known as the Panic of '73 caused a steady decline in mine production, and by 1876, all the mines and even the furnaces temporarily closed down. By 1877–1878, Oram and John Hance had the idea to build a forge in which pig iron could be rapidly refined and improved with new, modern machinery. Port Oram brushed itself off and got back to hard work, and by the 1880s, 80 percent of all of New Jersey's iron was produced in Morris County.

Along with the principal mines of the area, such as the Dickerson, Mount Hope, and Hibernia Mines, there were the Irondale Mines. Situated along Port Oram's southwest ridge and overlapping the Mine Hill–Ferromonte region were the Orchard, Hurd, Hoff, Bullfrog, Stirling, Harvey, Hubbard, North River, Corwin, Sullivan, and Spring Mines. There was little in common between most of these mines except their location on the same ridge. Although the Hurd, Harvey, and North River mines were opened on the same vein, each mine exploited an ore body entirely distinct from the others. Throughout the 1870s, these mines and many like them were worked for profit until they were either exhausted or idled by underground flooding. By developing a subterranean tunnel called the Orchard and Irondale adits, key mines such as the Stirling, Hurd, Orchard, and Harvey extended their production for years while gaining easy underground passage between the Morris Canal and the Morris and Essex Railroad.

Robert F. Oram retired as director of mining in 1881. He dissolved Oram, Hance, and Company in 1892 after buying the remaining interests from his partners and restructuring the general store under the name R. F. Oram and Company. Managed by his son, Robert F. Oram Jr., who also built a reputation as one of the ablest and best-known businessmen of Morris County, the business grew to include the general store, drugstore, hardware, plumbing, a tin store, and extensive lumber and coal yards.

Oram was also stockholder to the National Union Bank of Dover, the Newark Bank, the First National Bank of Morristown, and the Trader's National Bank of Scranton, Pennsylvania. Aside from all the properties mentioned, he also owned 75 houses in Dover, Rockaway, and Port Oram, attended the Presbyterian church, and was known as an independent in politics, voting only for the men he considered to be honest. Oram traveled extensively throughout Europe and was a frequent visitor to his homeland of England. When he came to this country there were no railroads and he walked from Morristown to Dover every day. Small forges carried the iron industry with material goods hammered by hand and hauled off to New York City by cart. There was little money then. Almost 50 years later, Robert F. Oram's great success was the legitimate outcome of well-directed, persevering, and honorable efforts. His capable management and unflagging enterprise led a small mining settlement out of the work camps and into the industrial age. Port Oram could now stand on its own.

The year 1884 brought more diversified industry in the form of silk mill weaving. The silk industry gave the female population of Port Oram a steady source of employment, and by 1889, the Gotham Mill expanded from its original building in the Pine Grove section and moved to the Washington Forge site to use the waterpower of Washington Pond and its newly heightened dam. After expansion under several owners, the E. J. Ross Manufacturing Company, or as locals penned it, "the Ross Street Mill," still stands today at the foot of Washington Pond and the Rockaway River.

By 1895, Port Oram's blast furnace, mine, and transportation center had grown into its own political voice. Oddly enough, for 40 years the borough, known to all in the state as Port Oram, was never officially founded. So on June 28, 1895, voters from all the settlements gathered at the Hance Hotel and voted 143 to 51 to finally incorporate as a town named after its founding father and christen itself Port Oram.

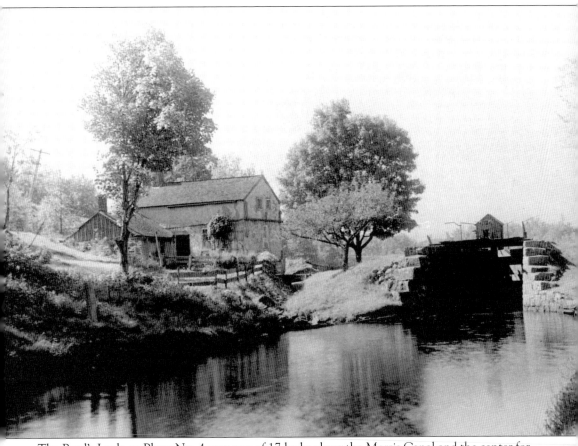

The Burd's Lock, or Plane No. 4, was one of 17 locks along the Morris Canal and the center for Port Oram's interstate transport, lowering and raising the canal's water levels as much as 60 feet to accommodate the various sized barges traveling from east to west. Since the tender's job ran 24 hours a day with ongoing shipments, the tender house became home to whoever was in charge of the waterway's ever shifting levels. It was last occupied by the Thomas Drake family. After the canal ceased operations in 1928, the properties were abandoned.

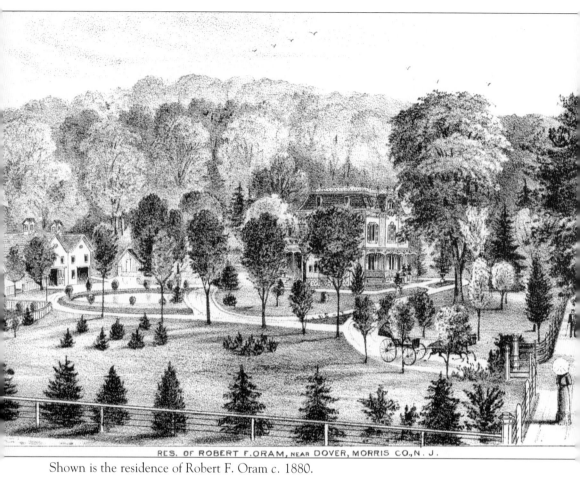

RES. OF ROBERT F. ORAM, NEAR DOVER, MORRIS CO., N.J.

Shown is the residence of Robert F. Oram *c.* 1880.

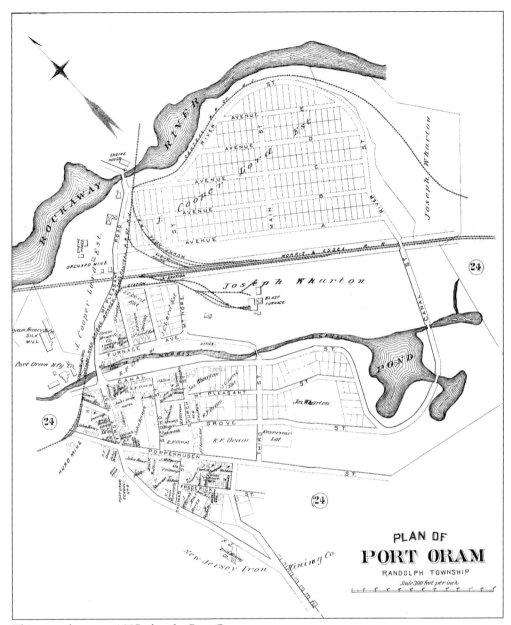

This map shows an 1887 plan for Port Oram.

19

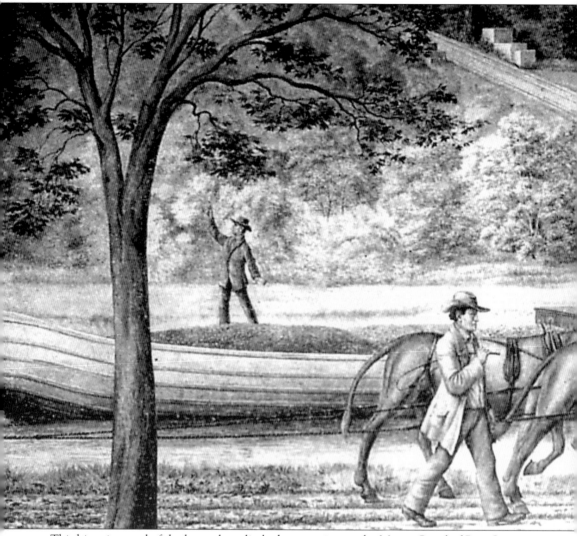

This historic mural of the boats that climbed mountains on the Morris Canal of Port Oram was painted in 1938 by Louis Valdemar Fischer of the Works Progress Administration Art Project. It is mounted on the wall of the council chamber of the Wharton Borough Hall. This representation of canal activities during the 19th century is authentic in every detail, showing

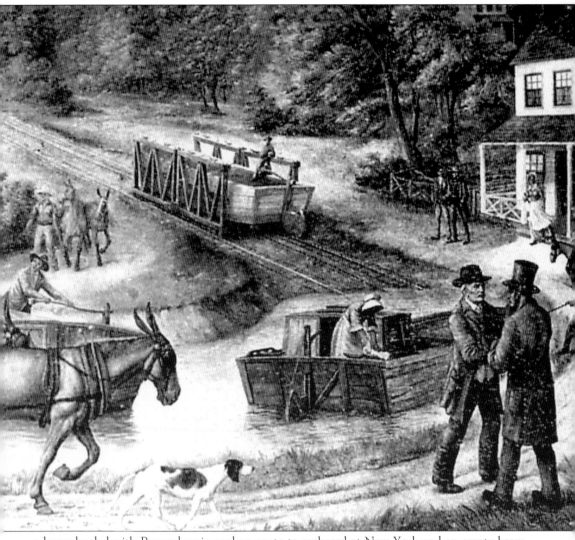

a barge loaded with Pennsylvania coal en route to seaboard at New York and an empty barge ascending the plane en route to the Delaware River. The cabins to the right housed the families of boatmen, while community life was centered on the towpath, where commerce paraded in its glamorous procession.

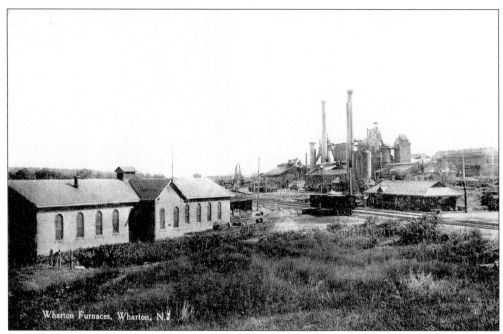

The Port Oram Blast Furnace (later known as the Wharton Furnace) was built in 1868 by the Port Oram Iron Company. The largest furnace in the country, it had a yearly capacity of 150,000 tons. The furnace operated until it was forced into bankruptcy during the 1873 depression. It was reorganized in 1877 under the name Port Oram Furnace Company. Later purchased by Joseph Wharton, the facility was enlarged and operated at an extensive scale until February 1911.

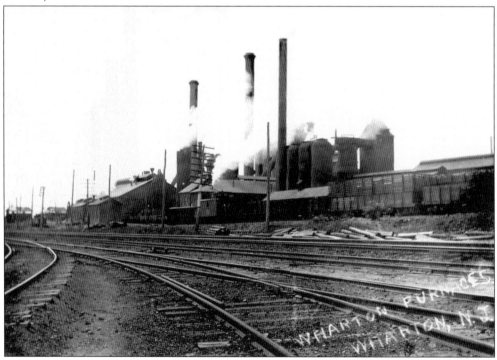

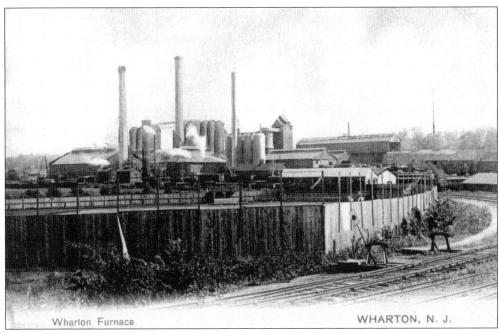

Wharton Furnace

WHARTON, N. J.

The Wharton Furnace is pictured *c.* 1902.

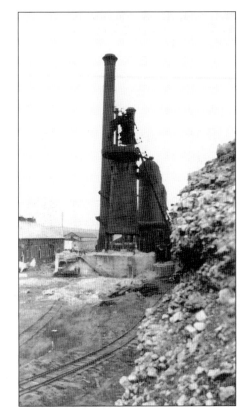

The furnaces were purchased and further improved by J. Leonard Repolagle in 1916, before another takeover by the Warren Foundry and Pipe Company. However, the low iron market soon forced closure in 1925, and the huge plant was dismantled to a junk pile in 1932.

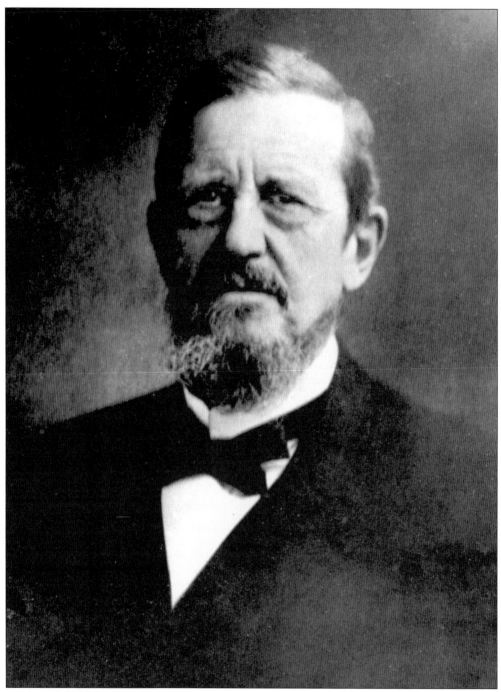

Born in Philadelphia, metallurgist Joseph Wharton bought the Port Oram Furnace in 1881 and rebuilt and modernized the local industry. By the beginning of the 20th century, he had built three blast furnaces and mined ore extensively throughout the region. He is considered one of the most significant figures of the iron era.

Three

THE NEW TOWN

OF WHARTON

The person for whom Wharton is named was, like his predecessor Robert F. Oram, a most remarkable man of business. Joseph Wharton was among the first to establish the manufacture of spelter, nickel, metallic zinc, and cobalt in this country and was the first to make magnetic needles of substances other than steel. He also played a major role in the coining of the American nickel. His activities in iron were prominent enough to have made him one of the most significant influences of the iron era.

Born on March 3, 1826, in Philadelphia to an old Quaker family, Wharton first studied at a local Friends school but did not attend college due to poor health. He was sent to a farm to regain his strength and studied chemistry at the laboratory of Martin Boye in Philadelphia. A metallurgist by age 21, he joined his brother in a venture to manufacture white lead. The business was later sold, and in 1853, he moved on to the zinc industry, first as manager of the Freidenville mines and then as founder and director of the Saucona Iron Company, forerunner of the Bethlehem Iron Company and later, Bethlehem Steel, where he would become director and stockholder until 1904.

Wharton married Anne Corbit Lovering, sister of his brother Charles' wife, Mary, on June 15, 1854. Together, they had three daughters—Joanna (born on December 16, 1858), Mary (born on September 27, 1862), and Anna (born on July 15, 1868).

By 1873, Wharton owned deposits of nickel ore in Lancaster County, Pennsylvania, and established his works in Camden. In 1876, he purchased the Batsto Iron Works complex at a master's foreclosure sale for $14,000. Originally constructed on the banks of the Batsto River, the site was a bog iron and glassmaking community founded by famous ironmaster Charles Reed in 1766. The ironworks changed hands numerous times; it was bought by John Cox in 1773, by Joseph Ball in 1779, and by William Richards in 1784. It remained in Richards' family, operated by his son and grandson, for the next 92 years. Wharton rethought the property and built a sawmill, cleared the land, planted cranberries and other crops, and ran a forest products and agriculture business until his death in 1909. (The state of New Jersey purchased Batsto in 1954, and today, it is the core of Wharton State Forest and part of the Pinelands National Reserve.)

Since the Bethlehem Iron Company was a large mine operator in Morris County, Wharton was very familiar with the area, especially Port Oram. He had operated only one furnace, the Warren furnace in Hackettstown, before selecting Port Oram as the location for his iron empire. He purchased the Port Oram Furnace in 1881 and proceeded with the rebuilding and modernizing of the local industry. Over the next 20 years, he built three blast furnaces and conducted extensive ore mining throughout the county. Anthracite fuel was replaced by soft coal bought cheaply and shipped in from western Pennsylvania for the coke ovens he erected. To transport his ore and not disrupt the central railroads, he put together his own railway system by constructing new lines and purchasing some smaller existing ones.

Wharton also had very definite ideas about education and founded the first collegiate business school in the United States in 1881. The Wharton School of Finance and Commerce at the University of Pennsylvania, recognized around the world for its academic strengths across every major discipline and at every level of business education, was a project very close to

Wharton's heart. He also shared directorship with Ario Pardee, another iron trade entrepreneur from Port Oram's blast furnace, on the Lehigh Valley Railroad and for 12 years stood as president of the American Iron and Steel Association.

In March 1902, Port Oram, which had only been a town officially for seven years, was renamed Wharton in honor of its principal industry and esteemed benefactor. By 1905, the town population had grown to 2,285 and employed 800. The first decade of the 20th century did indeed belong to Joseph Wharton, and he was also credited for the straightening and widening of the streets, curbing the sidewalks, cobbling the gutters, and improving the overall appearance of the borough.

Following a trip to Europe in 1907–1908, Wharton's health deteriorated rapidly, and he died on January 11, 1909, at the age of 83. He left an estate worth $14 million and was laid to rest in Pennsylvania's Laurel Hill, a favorite resting spot for many Whartons. His heirs shut down the mines and furnaces in 1911. The furnaces operated briefly during World War I and then closed forever. Only a few well-equipped mines would continue to operate until the end of World War II. A new phase of industry and life in Wharton had already begun.

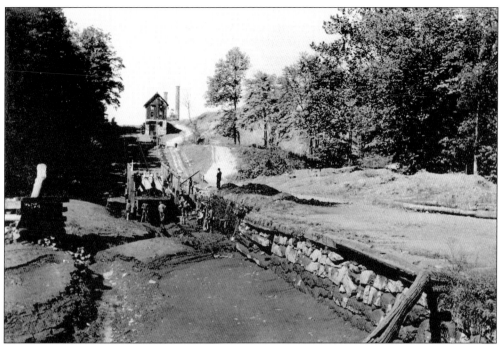

Shown is the lock below Wharton Furnace. Joseph Wharton's mammoth iron empire could be viewed from all ends of town.

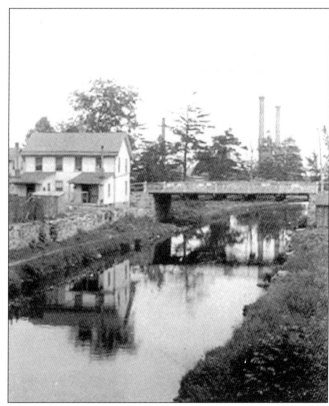

The Morris Canal is pictured running through the area now known as 13–25 Washington Street in this late-1800s photograph. Canal Street, today known as Fern Avenue, ran parallel to the canal and was only about 50 to 100 feet from its banks.

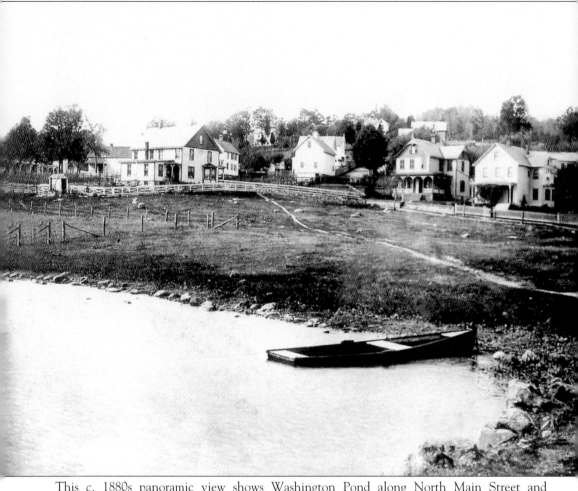

This *c.* 1880s panoramic view shows Washington Pond along North Main Street and

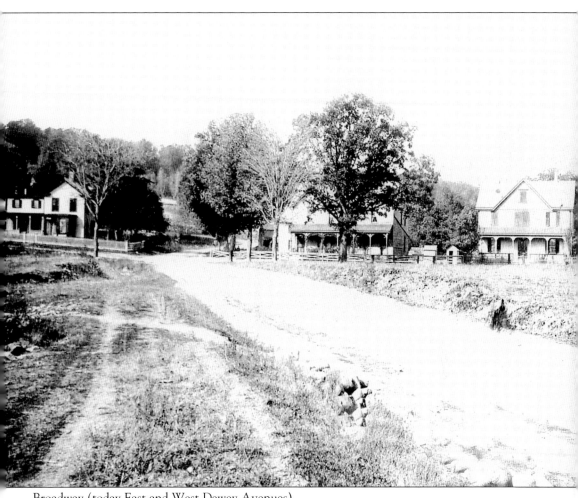

Broadway (today East and West Dewey Avenues).

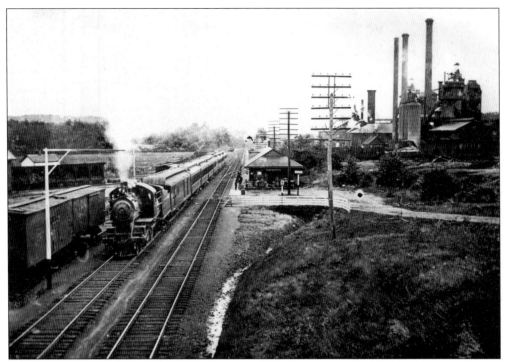

Pictured is the station of the Delaware, Lackawanna and Western (or Wharton) Railroad. The construction of the railroad began in 1835 and was completed in 1848 with access routes connecting Morristown and Dover to the Newark and Elizabeth (town) lines.

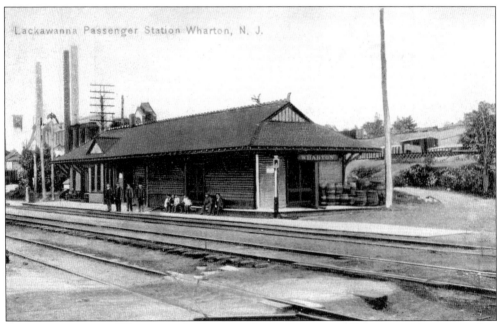

Passenger service to Wharton and all surrounding areas, except Dover, was discontinued in March 1932. By 1976, Conrail had absorbed all remaining passenger service.

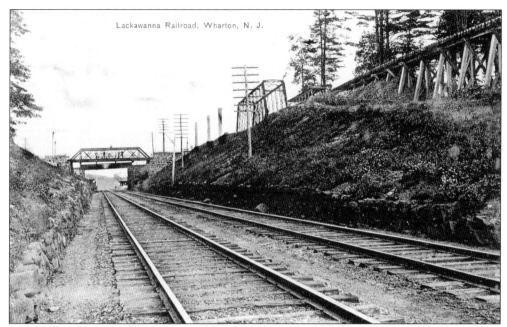

Lackawanna Railroad, Wharton, N. J.

In order to consolidate the numerous small iron-ore mine railroads and keep them separate from the main lines, Joseph Wharton built multileveled steel bridges and tracks at locations crossing over Main Street and Washington Street, leading directly to the blast furnaces. Shown are the Erie Lackawanna Railroad and the elevated service.

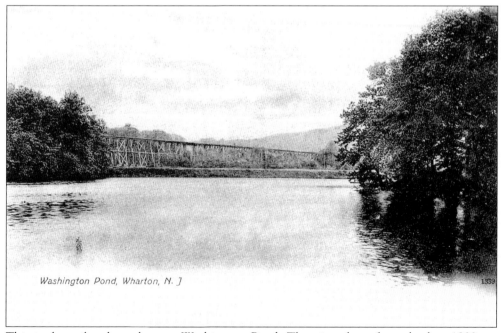

Washington Pond, Wharton, N. J

This is the railroad trestle over Washington Pond. The view dates from the late 1800s or early 1900s.

PORT ORAM

Booton C

Boonton Co.

Scale 30 Rods to the Inch

MORRIS

R.F.O

J.H.
Lumber
Shed

J.C. Lo

N.J.I.M.Co.

Tailor Sh.

B.S.Sh.

C.Sh.

Store & P.O.
Oram Hance &
Co.

Oram Hance & Co.

Freight House

Scales

Oram
& Hance

J. Hance

G. Hugger

R.E.
Oram

N.J.I.M.Co.

Oram &
Hance

M. Kitterich

J. Hance

J. Richards

chool

Oram & Hance
J. Mager

J. Hance

P.O.L.C.

Oram & L.
Groc
Allen W.
O'Conner J.
Hance Ise

B.Sh.

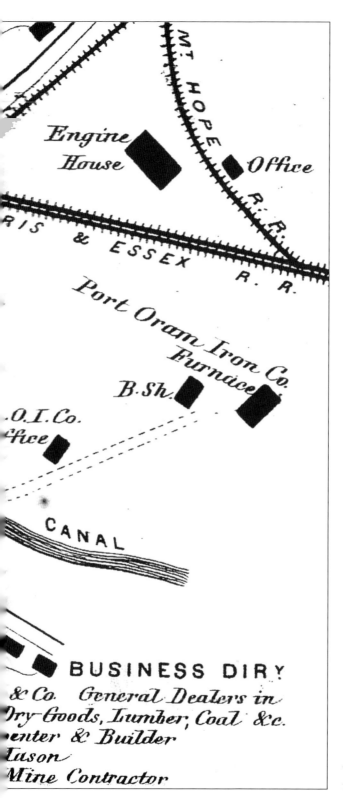

This is a Port Oram train map from 1868.

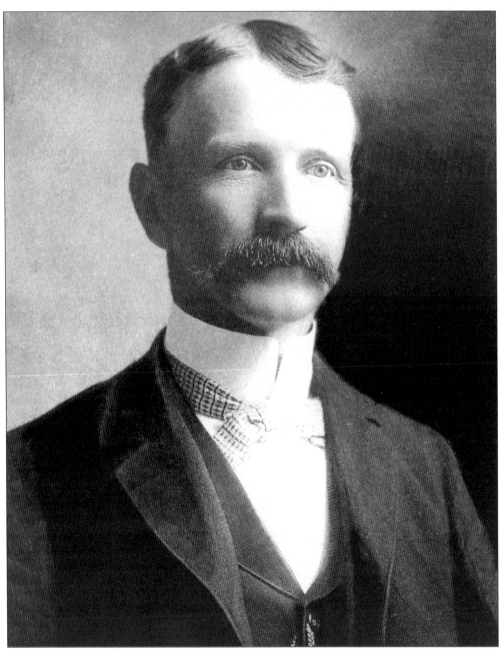

The Oram legacy of painstaking work and conscientious business ability enabled Robert Oram Jr. to secure an ample fortune. Born on December 12, 1861, he received his elementary education in district schools and studied in Providence and at Flushing Institute of Long Island, New York, before putting aside his textbooks to learn the more difficult lessons in the private school of experience. His first task was mastering the duties of clerkship of the prosperous Oram, Hance, and Company. In 1892, the extensive business was changed to R. F. Oram and Company with Robert Oram Jr. as chief manager. He was also appointed postmaster of Port Oram on January 1, 1897, and served as town mayor from 1909 to 1912. He married Lidie Neighbour of Dover in 1888 and had two children—Helen and Robert Maxwell Oram.

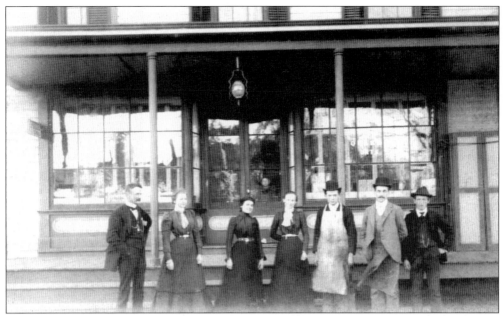

John Hill, an active local politician, owned the prosperous John Hill and Company store in 1860. Previously the site of a storehouse, the building on its top floor housed the Lord and Fuller Ticket Agency, providing steamship passage to England and Europe. Following Hill's retirement, Robert F. Oram, John Hance, and William Lathrop of Boonton took over the business in 1861 and called it Oram, Hance, and Company. The first post office desk was started inside the store on January 31, 1867, and John Hance was personally appointed Port Oram's first postmaster by Pres. Abraham Lincoln and remained until 1885. The store was located on Main Street along the Morris Canal and had its own loading docks. Pictured are Robert F. Oram, Josephine Williams, Katic Hitchons, Jane Williams Curran, two unidentified workers, and Fred Hance.

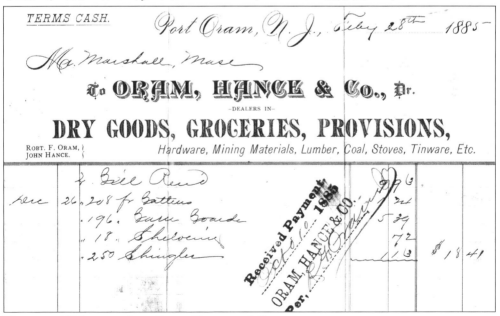

This is an 1885 receipt from Oram, Hance, and Company.

This building on West Central Avenue once served as the fire department, police department, town library, and the borough hall facility before local expansion and growth demanded separate institutions.

Shown is the Carling Home, or the Tollhouse. A toll road at Union Turnpike was chartered by the state legislature on February 23, 1804. It connected Morristown, Dover, Mount Pleasant (northern Wharton), Berkshire Valley, Hurdtown, Woodport, and Sparta. The tollhouse collected 2¢ per mile for each carriage, sleigh, or wagon drawn by one beast and an additional 2¢ for every additional beast. The old house, soon considered an eyesore, was torn down in April 1938 to improve the appearance of the property with the new, modern housings being built along the highway. All that exists of the heavily traveled Union Turnpike today is at Wharton-Rockaway Township and an area by Culver's Lake in Frankford.

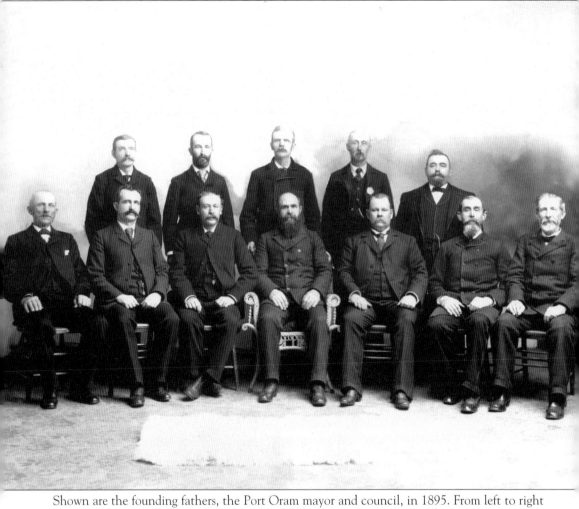

Shown are the founding fathers, the Port Oram mayor and council, in 1895. From left to right are the following: (front row) T. B. Tone, M. Mulligan, G. Dorman, W. V. Curtis (mayor), E. Mill, J. Curtis, and S. Davis; (back row) William Lumsden, E. W. Rosevear, E. E. Potter, William Hance, and H. Collins.

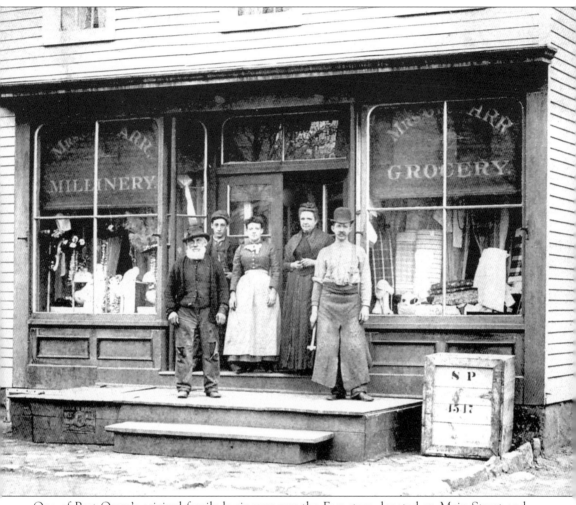

One of Port Oram's original family businesses was the Farr store, located on Main Street and Canal Street (now Fern Avenue). Shown here in the early 1880s, the business was established in 1860.

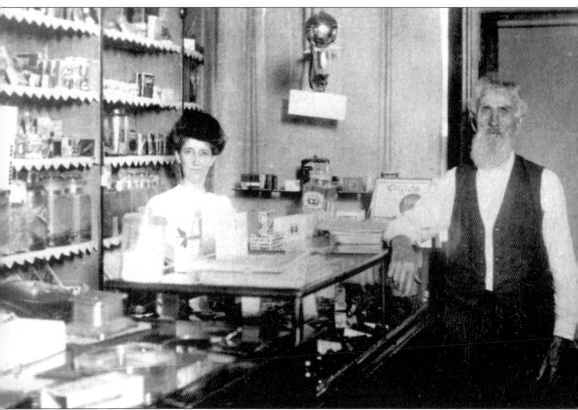

Mr. Farr (right), the proprietor of the Farr clothing and millinery store, also owned his own blacksmith shop, and his wife (left) ran the store. The building was sold to Ben Flartey c. 1882. Passed down to son George, Flartey's remained a family-owned confectioner for 66 years. In 1949, the business was purchased by William Danielson, who continued the confectionery and paper business for 25 years. The Wharton Building and Loan Association (established in 1928) took residence in the Danielson building as well as Harvey Leach Insurance Company (established in 1939) in 1945.

Pictured in the 1940s are George Flartey and his wife.

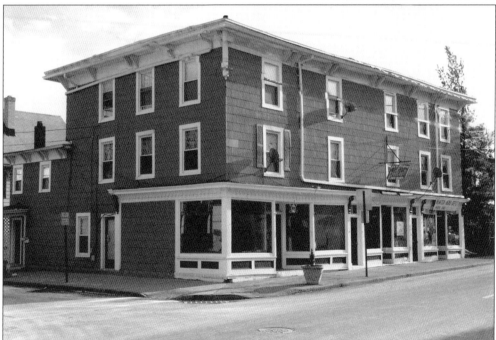

Since 1882, the building has been best known to locals as "the Paper Store." Today, it still maintains its quaint vintage appearance.

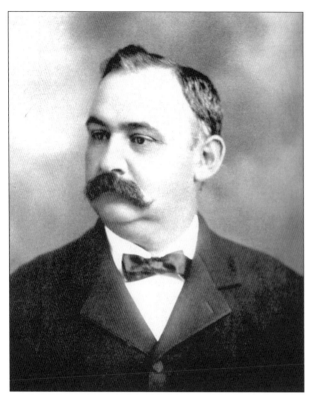

Edward Kelly, the manager of the Wharton Blast Furnace in Port Oram, was associated with the iron industry since early boyhood. Born in Oxford on October 15, 1858, Kelly was schooled and then worked in the rolling mill of his native city until the age of 21. He became timekeeper for the Boonton Blast Furnace and subsequently moved to the position of assistant manager of the Warren Furnace in Hackettstown before coming to Port Oram in 1883 in the capacity of assistant manager of the Wharton Furnace and Mines. Following the 1891 death of manager Tooke Straker, Edward was promoted to the position and also appointed treasurer and general superintendent of the Morris County Railroad in 1892.

A man of enterprise, energy, and marked ability, Jairus J. Langdon, was born on November 18, 1849, on the old Langdon Homestead in Morris County. He was educated at Rockaway Seminary and then employed with the Mount Hope Mining Company for four years. He became partners with Edward G. Coursen under their own general merchandising firm in Passaic County and expanded to a store in Hopatcong before purchasing his partners' interests and conducting business individually. He was appointed chairman of Port Oram's Republican executive committee and served as a member of the school board during the 1870s, while engaging in his own successful merchandising business on Union Turnpike (now Route 15) well into the 1900s.

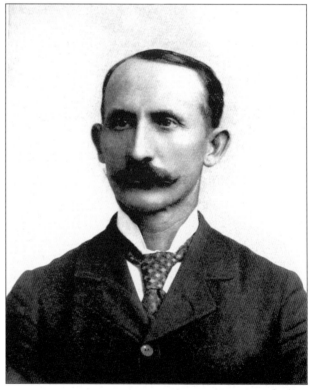

Edwin J. Ross was an important individual in the commercial life of Port Oram. Of colonial Scottish descent, he was born in the city of Newark on December 30, 1851. With a high degree of business acumen and integrity, Ross began his early career with W. V. Snyder and Company of Newark. At age 19, he entered the employ of Adriance, Robbins, and Company, jobbers of dry goods in New York City, followed by the wool firm of Hyde, Ayres, and Company. He embarked on his own business, and in 1883, he partnered the Hopper and Ross firm in Dover, manufacturing silk. After Mr. Hopper's death the following year, the company became Ross and Baker, with partner George B. Baker. In 1897, E. J. Ross Manufacturing Company succeeded Ross and Baker and moved the plant from Dover to Port Oram onto the 30-acre site that was the Washington Forge property. Manufacturing broad silk fabrics, fancy dress silks, grenadine veiling, and neckwear silks, the silk works afforded over 200 operatives, utilized the latest machinery, and manipulated both water and steam power from its banks on the Washington Pond and Rockaway River.

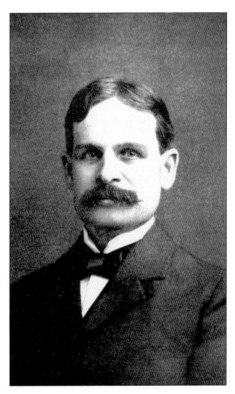

With the establishment of a borough, a police department and recorder's court became a necessity. Police Marshall William Hance was appointed Port Oram's first police officer in 1895. Port Oram's first jail was located in the basement of Hyman Freeman's Boot and Clothing Store on South Main Street and Poppenhusen Street. The first court was held in the Mount Pleasant Mining Company offices on the north end of Washington Street. Following in Marshall Hance's footsteps were Joseph Mankie, John "Tug" McDonald, William Bross, DeWitt Quinby, Everitt Dibble, David Jones, Abe Hocking, William T. Hocking, "Hank" Dombroski, Joseph Hornyak, and Anthony Fernandez.

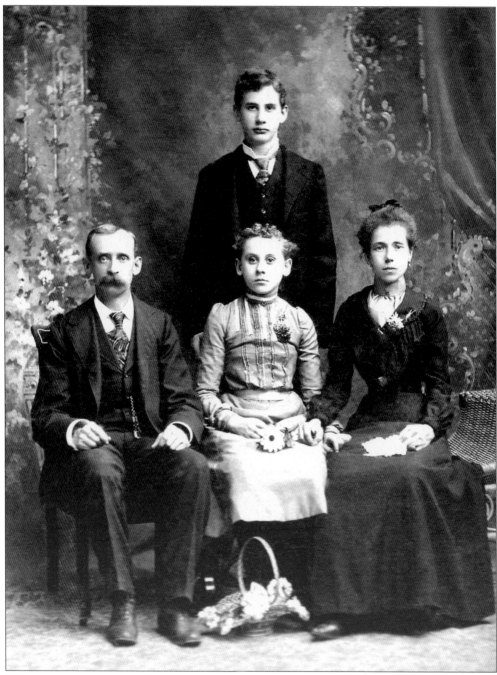

The writer William J. Fielding, best known for his 30 *Little Blue Books*, dealing with the "phenomena of sex, love, marriage and related subjects," may have certainly raised an eyebrow in the early 20th century. However, his books sold more than six million copies. Fielding is pictured at 12 years old with his father, stepmother, and sister Lottie in 1898. He resided on Washington Street before moving to Newark in 1905. His autobiography, *All the Lives I Have Lived*, chronicles his 80-year life story as a Wharton boy who left the blast furnaces behind him to become an internationally known writer.

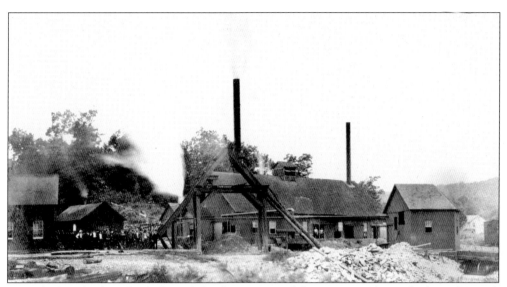

Named after the long line of Hurd family miners and forge owners dating back to the 17th century, the thriving Hurd Mine, first owned by the Thomas Iron Company since 1872, was active and worked steadily up to 1883. It closed for a few years and was reopened in 1904 to become a large producer for Joseph Wharton's Port Oram Furnace. A miner could garner a weekly salary of $6.60. Hurd Mine closed for good in 1911, soon after Wharton's death. The mine was originally located on what is now the corner of West Central Avenue and Robert Street. The Wharton Fire Department stands there today. Pictured are some of the Hurd Mine workers.

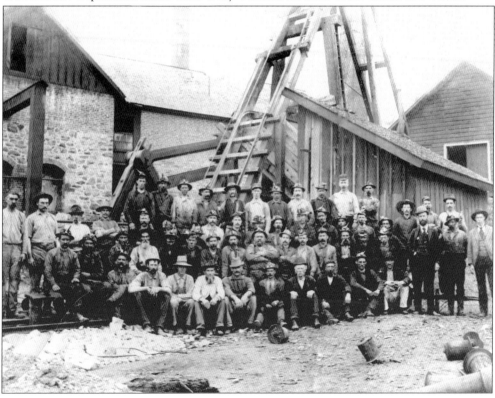

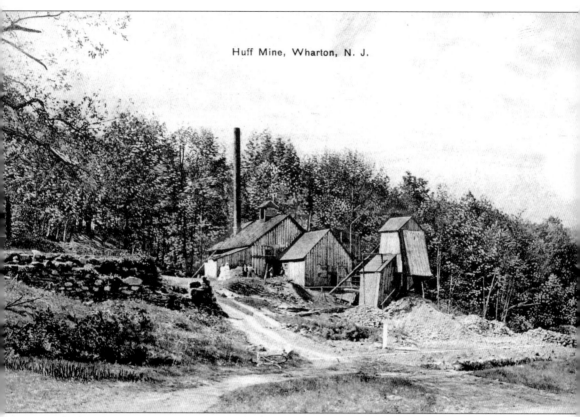

Huff Mine, Wharton, N. J.

The Hoff, or Huff, Mine was owned by Harriet "Hannah" Hoff, who was the last link in the Charles Hoff lineage. Mining commenced in 1872 on the old Moses Tuttle property of the Mount Pleasant settlement and was well noted for its "solid and clean" ore adapted to soft foundry iron. The mine was leased to the Chester Mining Company but not before disputes by Hoff's few distant heirs contesting her "sound" will were denied following her death in 1878. The Hoff Mine worked continuously until its closure in 1911.

Today, all that remains of the Hoff Mine's original location runs up the mountain along the south side of the Route 80 overpass and west of North Main Street. The two main shafts were located under the west abutment of the highway overpass. Huff Street, located toward the end of East Dewey Avenue, is named after the mine.

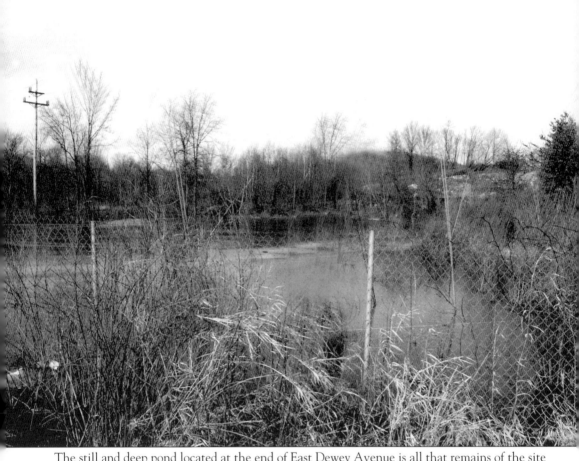

The still and deep pond located at the end of East Dewey Avenue is all that remains of the site once known as the Bullfrog Mine, or Meadow Mine. With a vertical shaft of 400 feet, the mine was abandoned in 1886 with a total aggregate production estimated at 75,000 tons. The name Bullfrog was comically termed after the area's large and noisy inhabitants.

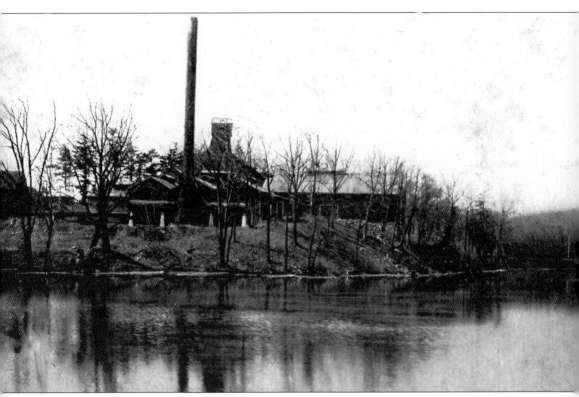

Founded on the Hance properties off the banks of the Washington Pond, the Orchard Mine was Port Oram's premier mine. Bought by the Boonton Iron Company and supervised by brothers Thomas and Robert F. Oram in 1850, this prize mine had a vein of 1,000 feet. Its workings were 400 feet long and reached 750 to 850 feet deep, with the addition of adits. The only way up and down was by ladder at 13 levels. By 1868, the Orchard Mine had produced more than 50,000 tons of ore. By the mid-1890s, its resources were exhausted, with an aggregate yield of 375,000 tons. It closed in 1910.

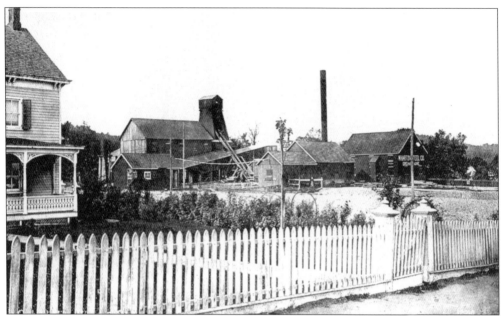

The lovely home seen to the left of the Orchard Mine is located at 99 North Main Street. It eventually became home to the William J. Hocking's Post No. 91 of the American Legion.

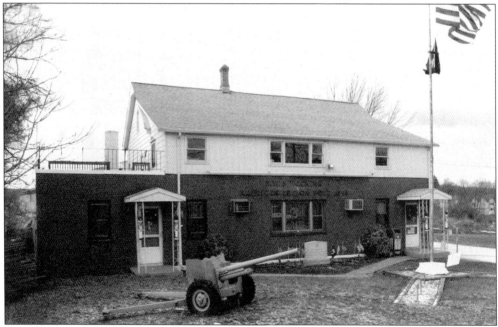

The local post of the American Legion was founded in 1928 in the town hall building on Poppenhusen and Roberts Streets. The post was named in honor of William J. Hocking, the first serviceman from Wharton to give his life for his country in World War I. The committee moved to its present site after purchasing the property from the defunct Warren Foundry and Pipe Company in the mid-1930s. At one time, the post had more than 400 members. It still sponsors American Legion Baseball, Boys' and Girls' State, and offers an annual student educational scholarship.

Shown are Thomas Street and Poppenhusen Street, which was named after Conrad Poppenhusen, one of Port Oram's early landowners and iron mine operators. The street is now known as Central Avenue. Conrad Poppenhusen bought his first home in 1867 at 17 Trowbridge Lane in Wharton's town center. Next to the Burrell Farm House, which still stands today at 149 North Main Street, Poppenhusen's Trowbridge Lane home is believed to be the oldest house in Wharton, dating as far back as 1753 and originally owned by Joshua and Augustus Ball.

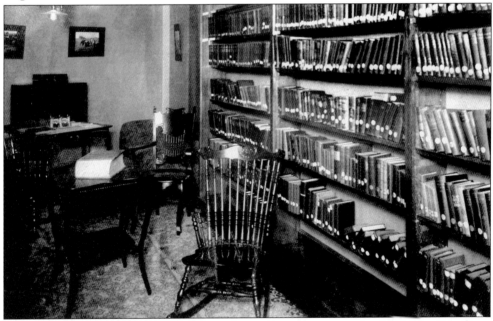

The Port Oram Library, at Main and Poppenhusen Streets, is pictured in 1899. The Port Oram Literary and Social Club was founded by Erastus Potter, J. Spargo, E. W. Rosevear, and C. E. Mill c. 1891. The club started with 700 books in a donated room at the Guenther Mill. After two years there, the books were kept in trust at individual homes in the borough before finally finding residence at the town hall in 1905. One of the first librarians was Annie Carpenter, followed by the dedicated Olive Champion, Anna Regan, and Catherine Z. Smith.

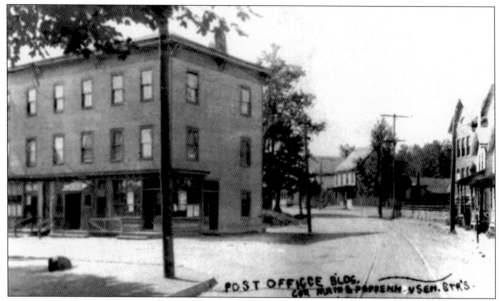

The post office stood on the corner of Poppenhusen Street (now East Central Avenue) and Main Street before moving back to its original space in the Oram and Hance store in the 1890s. In the early 1920s, it moved to a building directly across from the public school on South Main Street but then returned to the Oram and Hance building before finding permanent residence at the mall on North Main Street, originally known as Huff Field. The large building (pictured) is recognized today as the Corner Super Market.

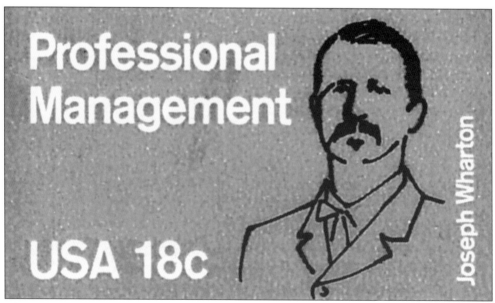

The Wharton postal stamp was created in Philadelphia and hand delivered to Wharton. The 18¢ commemorative postage stamp was cancelled on June 18, 1981, in honor and memory of Joseph Wharton.

The Ross Street Mill, pictured *c.* 1900, was also called the Ross and Baker Silk Mill. It sits adjacent to the Wharton Textile Company and Singleton's Silk Mill, which manufactured hosiery. Known by previous owners as the Gotham Mill, the mills of Wharton produced silk and materials from the 1880s and became the borough's principal industry in the first part of new century following the successive shutdown of the mines. In 1917, the entire complex was taken over by M. M. Searing and operated as the Wharton Textile Company until 1941.

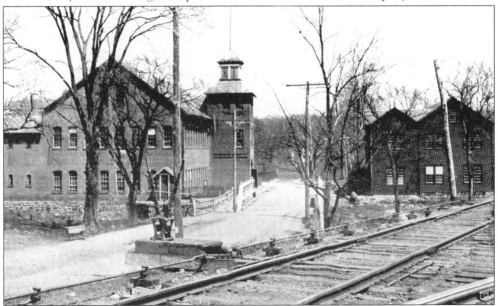

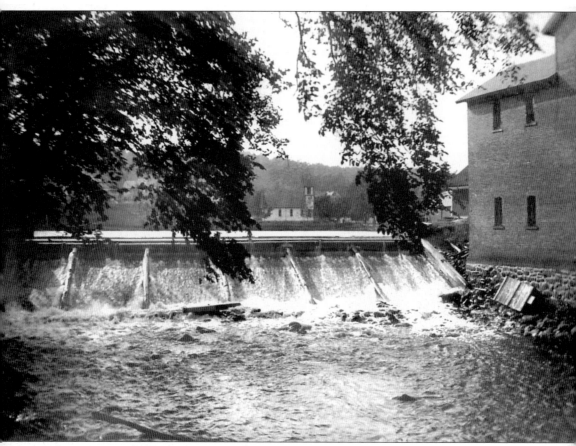

Crossing over the Rockaway River, this scenic dam was located at the end of the Washington Pond on the original site of the Washington Forge. The dam supplied power to E. J. Ross and Company (to the right).

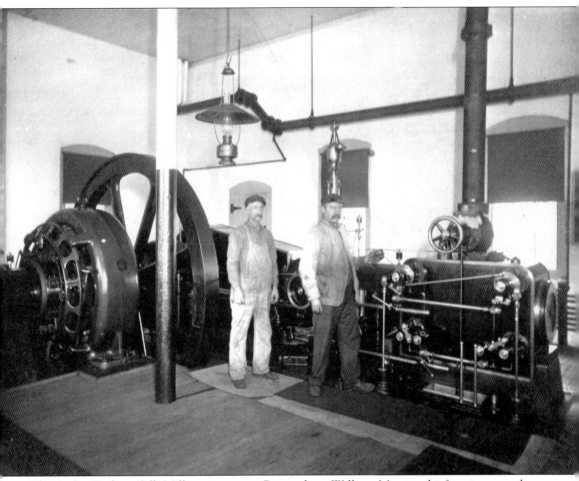

This is the Gotham Silk Mill engine room. Pictured are William Martin, chief engineer, and a coworker.

Erastus E. Potter, the original Yankee schoolmaster, was best recognized throughout the country as the most successful educator of the day and the ablest speaker and orator of his time. In 1896, the Honorable Garrett A. Hobart of Paterson, then vice president of the United States, commented, "I regard him as a man of high character and a great oratorical force. He is regarded by all Jerseymen, as a man whose efforts are always successful in making converts to the cause he represents. I have often wished he was a Republican and as earnest in our cause as I have known him to be in the cause to which we are opposed." This location (above) is the site of Port Oram–Wharton's first three public school buildings. In 1867, a one-room school was built here. The school district at that time was known as District No. 9, Randolph Township. It was replaced in 1882 by a two-story frame building with four rooms. When community growth caused a shortage of classroom space, some pupils were moved to the top floor of a three-story building at 2–4 South Main Street. The 1882 building was moved c. 1903 to the corner of West Central Avenue and Robert Street to become the municipal building.

Pictured is the Port Oram High School's graduating class of 1900. From left to right are the following: (front row) Nellie Hance, Elsie Losaw, and Kay Hambley; (back row) Tom Spargo, Erastus Potter, and Luther Rice.

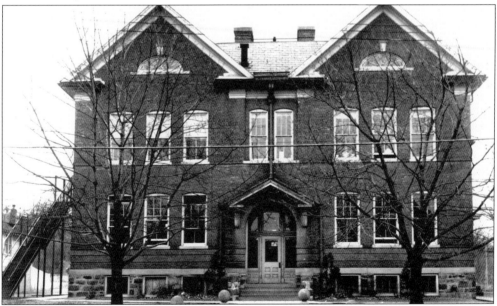

The new 10-room brick building was built *c.* 1903 and was named the Potter School following principal Erastus Potter's death at age 65 in 1906. The school was one of the first elementary schools to house separate classrooms for each grade, a system that caught on quickly throughout the country. The school closed in the 1960s and was demolished in the early 1970s. The Wharton Public Library now stands in its place.

Before the world wars, the island of land nestled between South Main Street and Oak Lane (seen here from the south) was called Oram Hill by Wharton's more bourgeois neighborhood and its long line of "hill house" owners circling the area. By 1931, a monument was constructed bearing the names of 104 local men who served in the armed forces in World War I and the 9 who died during the years of 1917–1918. The park then became known as Wharton Veteran's Memorial Park, or Military Park. A World War II monument was built in late 1946 at the southerly end of the park to honor the 506 men and women answering the call of duty during the war years of 1941–1945. A total of 14 young men gave their lives in that combat. In 1981, a Korean and Vietnam War monument was dedicated. One of Wharton's sons died in Vietnam. Today, the park remains a home for quiet contemplation and permanent tribute. The entire town gathered for a candlelight vigil for all those lost in the September 11, 2001, terrorist attacks.

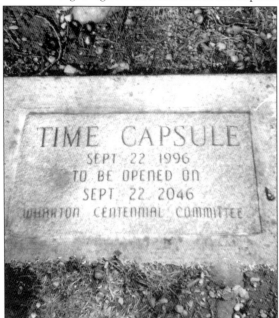

Sponsored by the Wharton Centennial Committee, a time capsule was planted on the southern part of Memorial Park on September 22, 1996, and will be opened on September 22, 2046. The capsule contains Wharton memorabilia, including essays written by Joanne Oriolo, Stephen Dangerfield, Steven Caamano, Angelica Harder, Ryan Stalter, and Erin Smith. All students were winners of a contest sponsored by the Wharton Centennial Committee, and their essays contain their outlooks on the present and future of the borough.

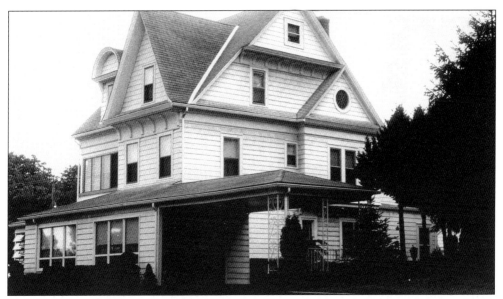

In 1892, Robert F. Oram Jr. erected this gracious Queen Anne–style homestead. Located on a lovely hill at 117 South Main Street (once nicknamed Oram Hill) overlooking Oram Hill Park (now Memorial Park), the area was referred to as the "choicest spot in town to live" at the turn of the century. Legend has it that in the early 1900s, Robert Jr. built the Colonial Revival brick home a few doors over at 99 South Main Street and presented it as a gift to Jane Williams Force Kearns. She was supposedly his mistress, and such gossip prevailed for more than 80 years. Wharton's own obstetrician, Dr. Raymond J. Grant, known to many as "Doc Grant," or "R. J.," and his sophisticated wife, Athol, purchased the residence in the 1940s. They lived there for more than 50 years, and for a time it was considered quite the showplace.

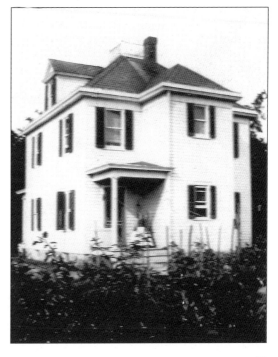

This is the Downs Home on Baker Avenue c. 1900. John Downs and his wife, Mary, established the Downs Store in the early 1870s at 336 South Main Street. Their stock in trade included groceries, meats, dry goods, notions, and tobacco. Passed down to son William John Downs in the 1930s, the family business continued until 1940. Though the original building has been completely altered and is now owned by three separate businesses, the store is best remembered to residents as Paul's Liquors. Downs Avenue was named after the family, who resided in a lovely home on Baker Avenue. This entire residential area in the Marysville, or St. Mary's, section of Wharton became known as the Downs Tract after World War I. It encompassed Downs, Ford, Summit, and Kitchell Avenues and Orange, Cutler, and Walnut Streets.

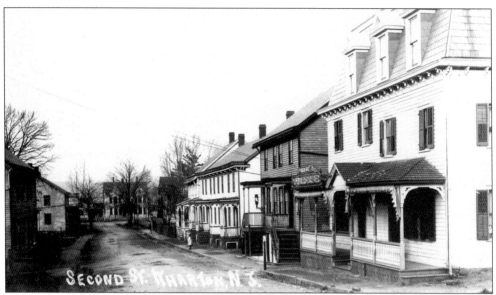

The Wharton House, also known as Widow Loughlin's Saloon and the Union Hotel, was located at 10 Second Street and built in the late 1880s. This long forgotten establishment may have even rivaled the popular Heslin House. Shown above in its early days along a strip of row houses, the local saloon and boardinghouse-hotel updated its image by adding balconies, as seen below. Today, the building serves as a multifamily dwelling. Wharton was no stranger to saloons, and at one time there were more than 13 serving the community within its two-mile radius. Some favorites were Mill's Tavern, Floyd Kimble's Oak Tree Inn, Ego-3, Winkie's, Freddy's, Peanut Shack Tavern, Jimmy Martin's, Charlies (or Freddies), Pop Mitchell's, Carberry's, Singleton's, and the Old Homestead (at the trailer park on Route 15).

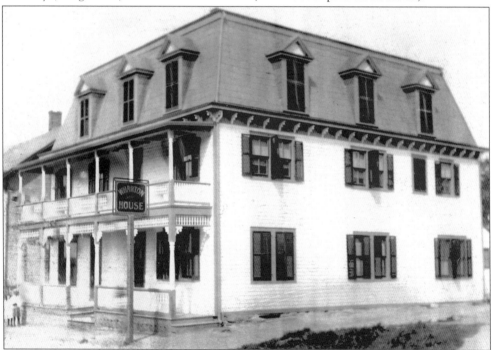

Pictured is the Wharton Bottle Company, at Pine and Main Streets, in 1905.

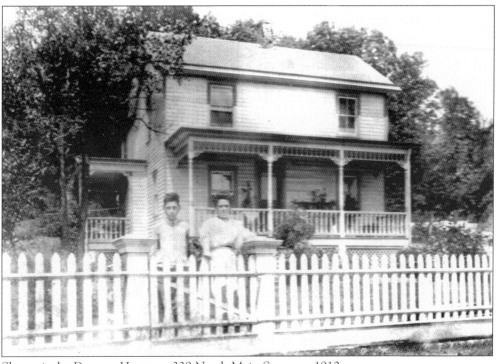

Shown is the Dorman Home, at 339 North Main Street, *c.* 1910.

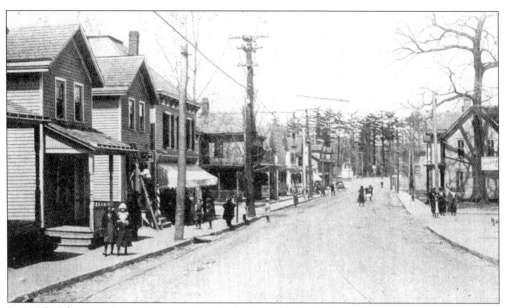

In 1905, Wharton's Main Street was expanding as always.

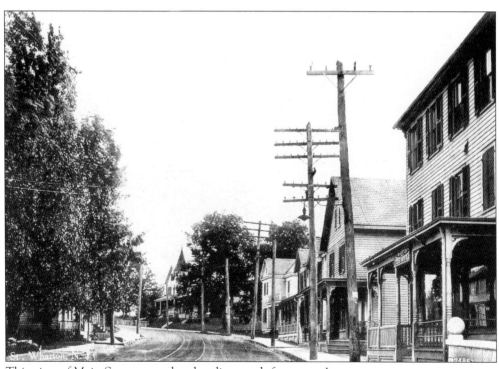

This view of Main Street was taken heading south from town's center.

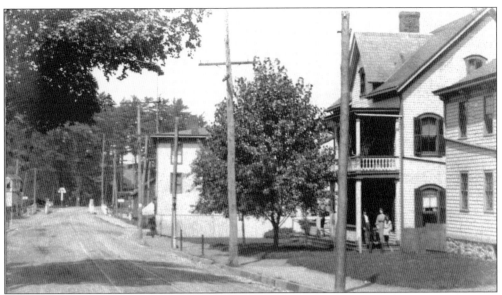
North Main Street is pictured in a view looking toward the furnace and Pine Grove.

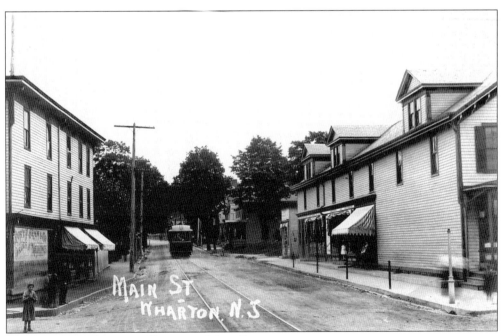
This 1912 view shows a trolley car on Main Street.

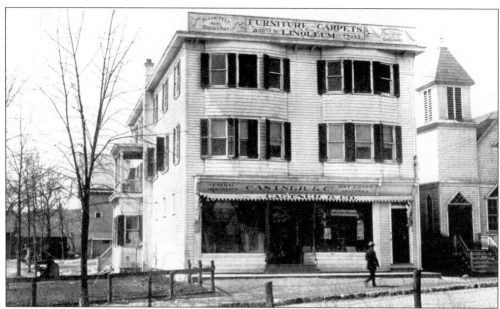

Castner and Company, on North Main Street, was the first full-service department store serving the Luxemburg area and was also reputed to be the last general store in the county. It was established in 1895. Miller P. Castner, a Flemington resident, bought the property from the Ross Silk Mill to establish one of the most thriving businesses in town. Within a distance of six local mines, Castner's carried everything from coal to lumber, refrigerators, vacuum cleaners, clothes, notions, and every supply a miner required. It had its own butcher shop, icehouse, six coalbins, a carriage house, and a barn to store grain. Before his death in 1912, Castner replaced the original building with a three-story, steel-girded building in 1911 (pictured). The family business passed from generation to generation before closing its doors in 1956. Daughter Mildred Castner Porter remembers the store as "the Bamberger's of the area and the center of social life for some time." Today, the building serves as the equally popular Sussex Meat Packing.

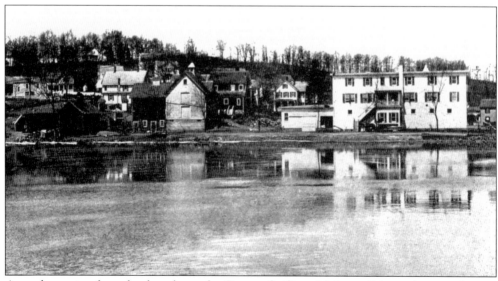

A northern view from the dam shows the Castner facility with its coalbins and storage barn.

Shown are Washington Pond, formerly known as Washington Forge Pond, Castner's Pond, and Castner's icehouse (right), which belonged to Castner and Company. Here, power for all the industries along the bank was generated. The pond also served as a natural year-round recreational area for swimming, ice-skating, fishing, and boating.

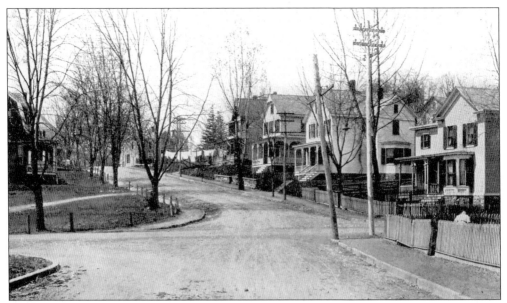

The Broadway–Main Street intersection at the base of the Luxemburg area in northern Wharton was the main thoroughfare connecting Kenvil to Dover. Broadway, which split at Main Street, was renamed East and West Dewey Avenues.

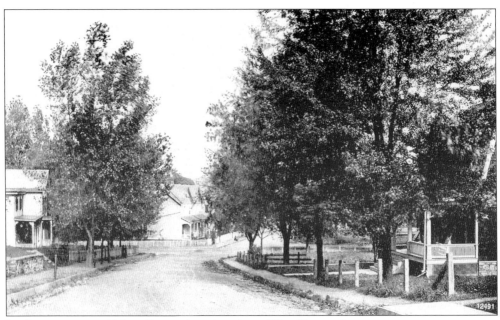

Looking east toward Main Street, this view shows West Dewey Avenue.

Pictured is the Reilly House, at 30 East Dewey, in 1905.

The Martin House, located at 34 West Dewey Avenue, is featured in this 1905 photograph.

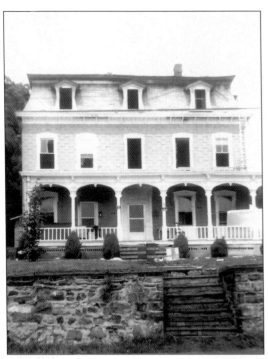

The house at 69 West Dewey Avenue displays one of Wharton's varied architectural styles.

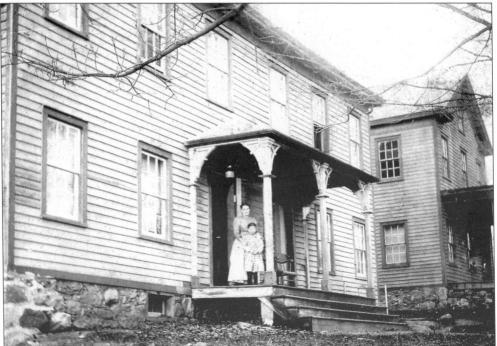

This is a fine example of the foursquare double house many workers and their families lived in on South Main Street at the turn of the century. Pictured are Doris "Tregenza" Bone's mother and grandmother c. 1900. Her father, James Tregenza, owned and edited the *Wharton Chronicle* on East Central Avenue. Its first publication was released on June 18, 1936, and it ran for only two years. There has not been a local newspaper since.

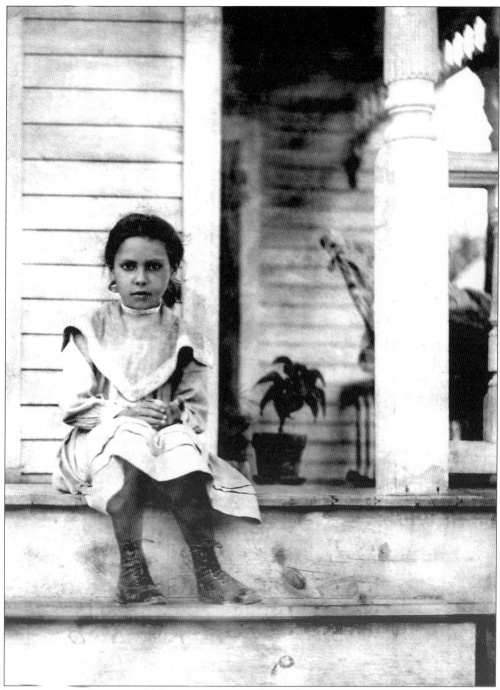

This is a c. 1900 portrait of Alma Oliver-Honeychurch. Born and raised in Wharton, she grew up to become a Wharton schoolteacher in the Potter School. After she married Fred Honeychurch, she became one of three Honeychurch women teaching in the Wharton school system; the other two, Effie and Edith, were her sisters-in-law. Alma Oliver-Honeychurch lived her days peacefully in the lovely turn-of-the-century home she was raised in, at 15 Ross Street, just across the street from Washington Pond.

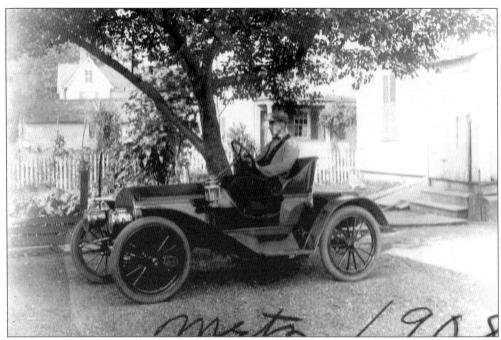

Irish immigrant and entrepreneur John A. Birmingham purchased the first car in Wharton in 1908. At the time, cars were prohibited from traveling faster than six miles per hour. "What's good for horses is fair for autocars" was the local rule. John operated a tavern and a barbershop at 292 South Main Street for several years prior to 1905. After completing the necessary education, he started an undertaking business known as the Birmingham Funeral Home. Passed down to son John C. Birmingham, the family business at 249 South Main Street remains today as one of Wharton's oldest standing establishments.

John A. Birmingham was born in 1876 and died in 1937. It was written in the *Wharton Chronicle* of May 13, 1937, "Charity he practiced. Not only through his affiliations with charitable organizations, but through those cherished acts in private life, many of which will probably never be known of, except to the actual recipients."

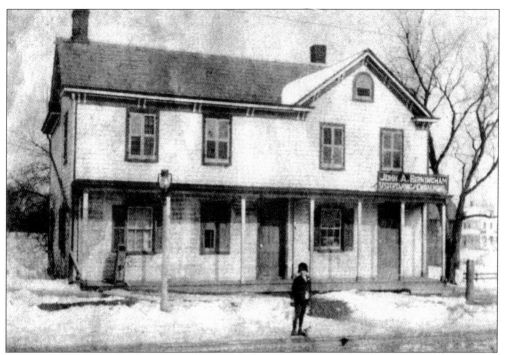

Resident Henry Gorman stands in front of Birmingham Funeral Home, on South Main Street in Wharton's Marysville section, in the early 1900s. In April 1921, Gorman became proprietor of his own family-run business, occupying the building next to his home at 276 South Main Street. Called Gorman's Store, it sold ice cream, tobacco, newspapers, and notions.

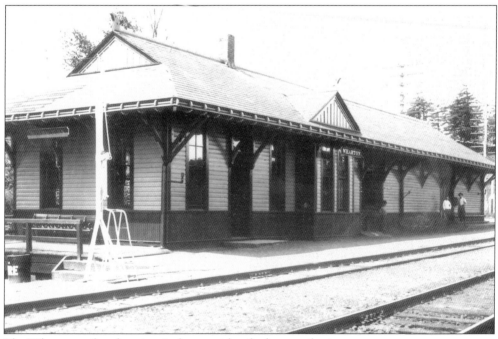

The Wharton railroad station is shown with a fresh coat of paint.

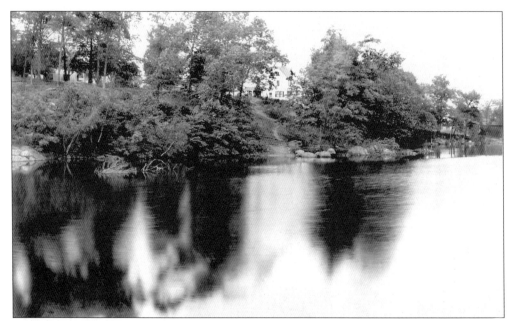

Here is a picturesque view of the towpath leading down to the swimming hole at First Rock in Washington Pond c. 1910. For years, a long cable hung from the highest oak on the top of the hill's precipice, and only the bravest youths would swing 30 feet out into the air for an impressive dive. The house standing on the hill is 34 West Dewey Avenue. If you traveled west on the path along the pond, you would come to Second Rock (far left corner), a deeper area of the pond for the more experienced swimmer and diver. Directly across the pond were the mines.

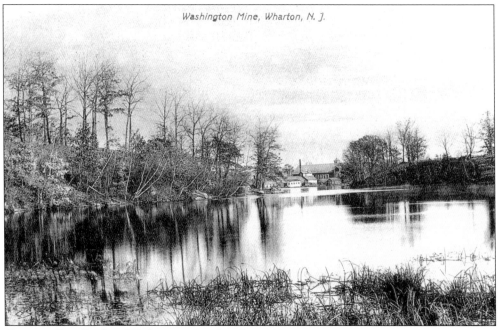

Shown is First Rock in Washington Pond c. the 1900s.

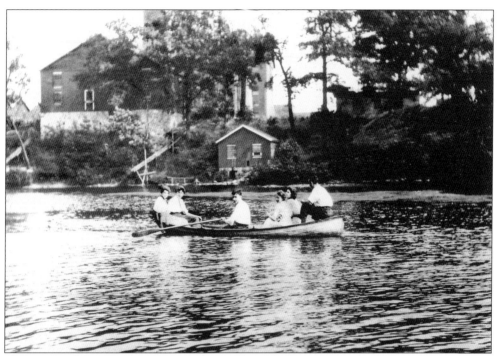

This scene reflects the enjoyment people got from Washington Pond.

Taken from Castner's driveway at Washington Pond c. the 1950s, this view shows the Kimble house, at 3 Ross Street.

A native son of Wharton, Dr. Nicholas Bertha, seen here with his father in 1910, is one member of a long line of respected Port Oram (Wharton) general practitioners. The borough's first resident doctors were Dr. J. Walters and Dr. Henry Kice (Port Oram's mayor in 1899), followed by the popular Dr. Ed Carberry. During the Depression and the 1930s, many expectant moms were still having their babies in a home environment instead of in hospitals. Dr. Orlinda Carpenter of 132 South Main Street had her hands full delivering the majority of new local residents at her home, known for years as "the Midwife's House." "Doc Bertha" soon came onboard along Dr. Walters Jr. with notable town physicians, Dr. R. J. Grant, Dr. Carlton, Dr. Bobadelia, Dr. Kovalesky, and the recently retired Dr. E. Forbes, a Wharton native himself. With Dover General Hospital so close by along Route 46 at the end of South Main Street, it was very convenient for all doctors within the town's two-mile radius to receive quick emergency attention for their patients when needed. Ironically, Dr. Kice, Dr. Carberry, Dr. Bertha, and Dr. Forbes each occupied the home at 57 South Main Street during their terms as town physicians. Dr. Grant and Dr. Walters occupied the neighboring large "hill houses" on either side. Recently, St. Clare's Hospital in Dover (originally Dover General Hospital) honored Bertha with a new regional cancer center wing in his name. Today, Wharton's only practicing physician is Dr. Lisa Ruml.

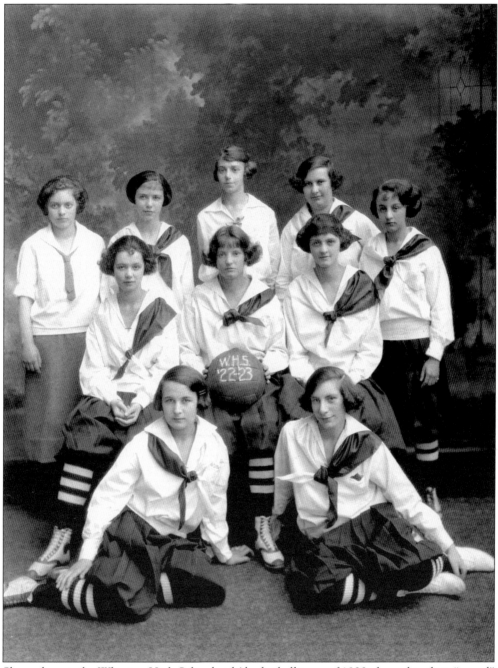

Shown here is the Wharton High School girls' basketball team of 1923, dressed in their "casual" uniforms and hairdos of the day. Times certainly have changed.

The Pythian Opera House, or Hopewell Lodge Building, was home to the Pythian Sisters, the Knights of Pythias, and the Masonic Lodge (since 1886). Located at 22 Baker Avenue, it was its parent organization, the Miner's and Mechanic's Benevolent Association (established in 1870), from which the organization stemmed. Instituting the beliefs, practices, and comradeship of the Freemasons (including the secret rites), they were known particularly for their charitable work. The opera house organized bazaars, put on plays, and performed "tasteful" musical shows. During the 1940s, the building was used as a local banquet hall to sponsor the local sports teams. The Pythians and Masons moved to the new North Star Lodge on South Main Street in 1958. Today, the opera house is a multifamily dwelling.

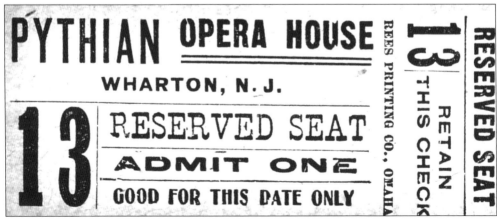

This is a ticket to the Pythian Opera House.

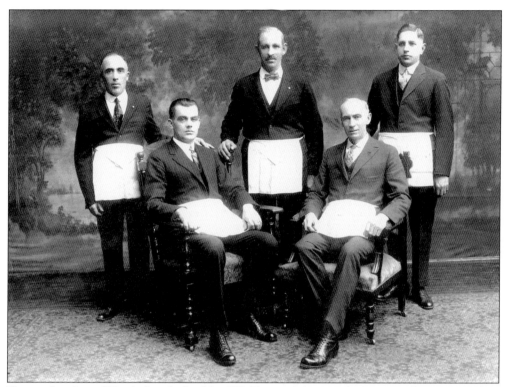

Here is the class of North Star Lodge No. 255, Free and Accepted Masons, Wharton, raised on June 17, 1925. From left to right are James H. Tregenza, Lewis K. Larrison, Robert W. Mclennan, James W. Dowson, and John Chappell.

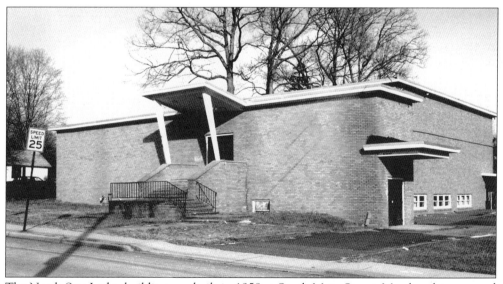

The North Star Lodge building was built in 1958 at South Main Street. Members later merged with the Dover Masonic Lodge due to low membership.

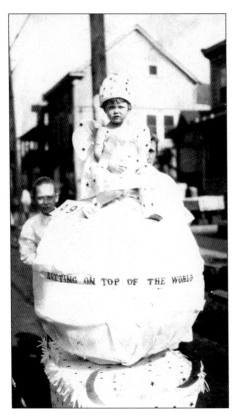

"Sitting on top of the world" was the theme of the annual baby parade held in Wharton in 1922. After weeks of planning, every mother was sure to have her "baby" coiffed, costumed, or riding the most adorable float in hopes of taking home the grand prize silver cup.

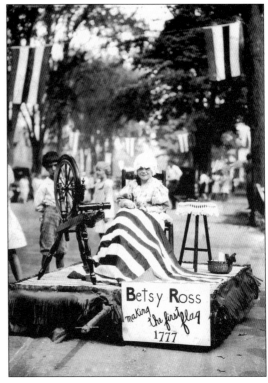

Even a float for Betsy Ross making the first flag was part of the parade.

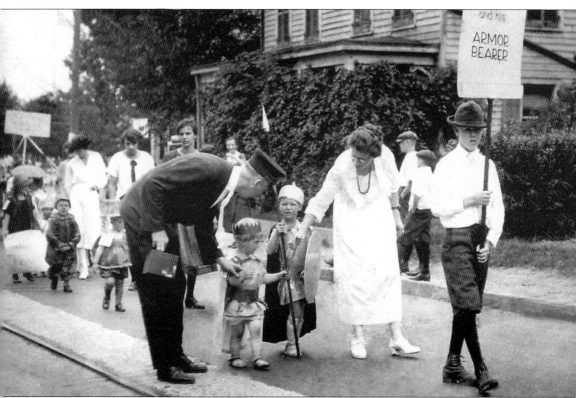

Brothers Albert and Martin Trengrove, flanked by their proud parents, march along South Main Street as "King David and his Armor Bearer." Martin Trengrove, whose family roots trace back to Cornish miners arriving in Port Oram in the 1870s and whose family was later recognized for Trengrove Insurance Agency on Main Street and Central Avenue, would himself become part of Wharton history as Wharton's fire chief in 1952 and as originator and president of the Wharton Historical Society. What started out as a hobby for Martin, collecting photographs, maps, documents, and the histories and local stories from older residents, proved to be a major occupation. He has proven to be an invaluable source of facts and information and is reputed as Wharton's town historian.

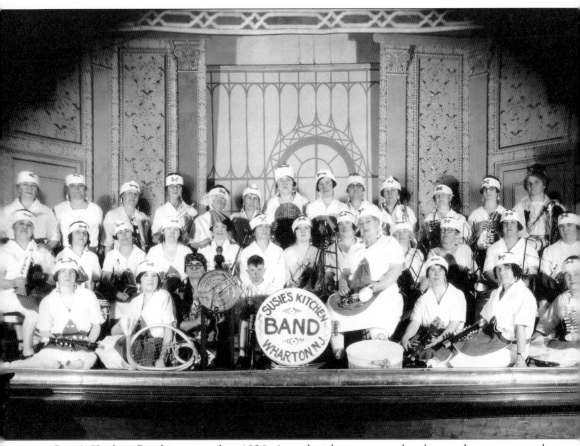

Susie's Kitchen Band is pictured in 1926. Armed with pots, pans, bowls, wooden spoons, and any percussion a kitchen cupboard could provide, the band, headed by Nell Hayford, was made up of a talented female force of parishioners from St. John's Methodist Church and performed steady gigs for more than 20 years.

On Saturday, July 10, 1926, at 5:15 p.m., a bolt of lightning struck the Lake Denmark Naval Ammunition Depot (now Navy Hill of Picatinny Arsenal) and started a fire in a temporary magazine holding 600,000 tons of TNT. The force of the blast set off two adjoining magazines, one holding 1.6 million pounds of TNT, the other adding to a total of 2.5 million pounds of explosives. The blasts rocked Wharton and neighboring towns to their knees, and locals headed for Pennsylvania in fear of further detonations. Because it was a Saturday, only 19 people died. This was the first of a trio of explosions that shook Wharton in the 20th century; the second was the Hercules Powder Explosion in Kenvil on September 11, 1940, and the third was a gas leak explosion under Main Street on January 11, 1984. This photograph shows some of the Lake Denmark aftermath.

This view of West Central Avenue was taken looking east in the late 1920s or early 1930s. With Main Street at its center, West Central Avenue and the Irondale section (shown here with its row of worker's houses built *c*. the 1880s) was the hub of Hungarian residency *c*. 1910. The Hurd Mine was directly across the street, and the firehouse is seen to the right. Kossuth Street, originally named Furnace Avenue and wedged between Main and Washington Streets, is named after Hungarian patriot Louis Kossuth, "the George Washington of Hungary." Kossuth Hall, which was once an office building for the Wharton Furnace sitting along the Morris Canal, became a popular social club for the new ethnic composition of the neighborhood and was home to the Louis Kossuth Workingman's Sick and Death Benefit Society for decades. Today, it is an eatery appropriately named the Canal House.

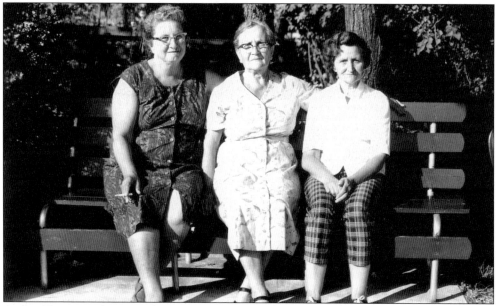

At this Hungarian homestead, Margaret Harding, Mary "Gramma" Garanyi, and Sophie Gorog take in a sunset in the early 1960s to catch up on life, local news, and stories of the old country. For years, the park bench they frequented nightly sat on West Central Avenue along the Erie Lackawanna train tracks across from borough hall.

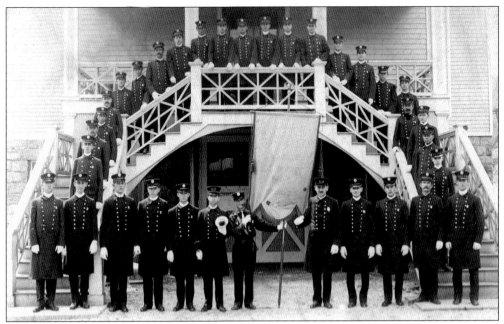

Wharton's Indie Hook and Ladder Company, pictured in 1912, was voted number one in the state for decades and was best known for their superior drill team. In 1902, a citizens committee was organized to establish the Wharton Fire Department. It was not finalized until 1904.

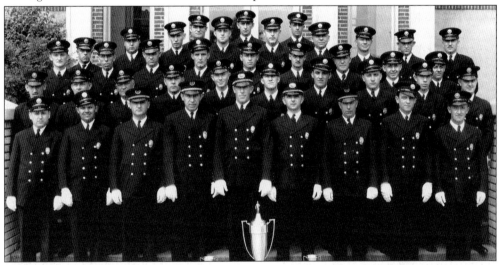

The Wharton Fire Department and Drill Team poses on June 20, 1936, with the state champions' Governor's Cup. From left to right are the following: (first row) Arthur Wargo, Andrew Risko, Francis Waters, Nicholas Stefanic, Robert McLennan, John Waters, Arthur Somerville, Wilbur Champion, and William G. William; (second row) Steven Lawrence Jr., unidentified, Willam Rowe, Anthony Levoy, Carl Nelson, Arthur Richards, Thomas Lewis, Emil Saloky, P. Elroy Chegwidden, and Richard Rowe; (third row) John Shohan, Kenneth Bragg, David Malcolm, Nicholas Garanyi, unidentified, Herbert Saxe, John Williams, Fred Prandato, and Cornelius Martin; (fourth row) Wilbur Skewes, Raymond Eustice, Raymond Little, Walter Hoffman, Lloyd Mathews, Joseph Shohan, Donald Post, Leslie Mathews, Johnson Holley, William Morford Rowe, John Ware, and unidentified.

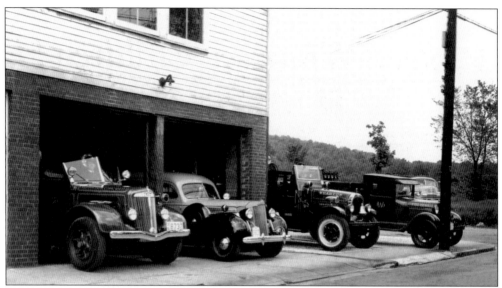

Seated with Wharton Fire Department fire engines of 1941 is Fire Chief William Rowe. On display are the town's latest acquisitions: an ambulance and a brand-new fire truck with a 500-gallon, two-stage centrifugal pump and full compartments carrying 150 gallons of water in a booster tank. The two antiquated vehicles on the right were called the Buffalo pumpers. They came after the first gasoline-motorized equipment was purchased and placed in service in 1916, replacing the old-fashioned hand- and horse-drawn hook-and-ladder wagons with running boards originally donated to the department by Robert F. Oram. The actual fire department was located on the ground floor of borough hall, before moving across the street to a new building on the old Hurd Mine properties in 1970.

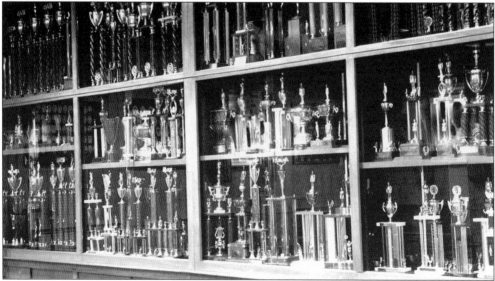

On display in the Wharton Fire Department trophy case is a first prize that dates back to 1908. Throughout the years, Wharton's Indie Hook and Ladder Company has appeared throughout New Jersey, New York, and Pennsylvania and has won well over 600 trophies. This complete wall of cups, medals, trophies, and awards represents a mere one-quarter of the Wharton Fire Department's entire and impressive collection that is still growing.

Protect Wharton Children!!

M R. MOTORIST:— You may forget you ever saw this cartoon, but if, some day after a moment of carelessness or neglect, you have to stand by and watch as they remove the broken, lifeless body of a child from under your car—YOU'LL WISH TO GOD YOU COULD FORGET! Children are not responsible for their thoughtlessness—YOU ARE!

DEATH IS RIDING AT THE WHEEL WITH YOU, waiting for a moment of carelessness on your part to reap another victim.

You'd better think about this—it pays.

The Wharton Chronicle

20 East Central Avenue WHARTON, N. J.

This *Wharton Chronicle* advertisement ran in August 1936.

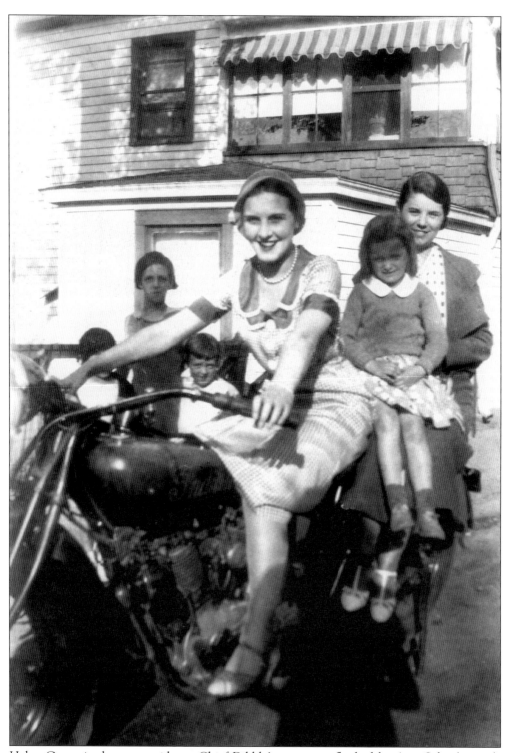

Helen Garanyi takes a test ride on Chief Dibble's motorcar, flanked by Ann Sabo (sitting), Jeanette, JoJo, and Thelma Dibble in the early 1930s.

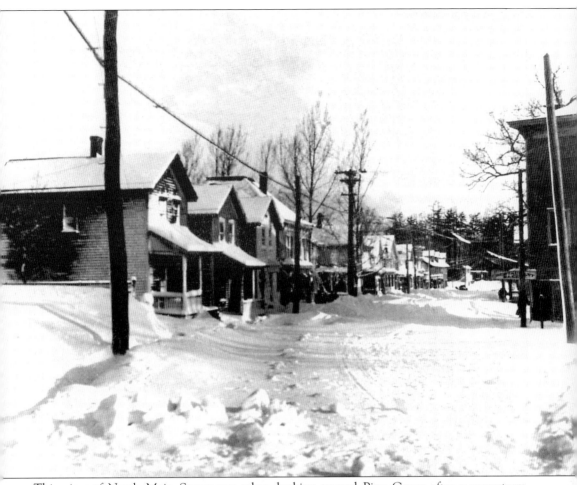

This view of North Main Street was taken looking toward Pine Grove after a snowstorm *c.* the 1930s. The building on the right corner of Fern Avenue once housed the Fern Restaurant, which later became the popular Singleton's Café.

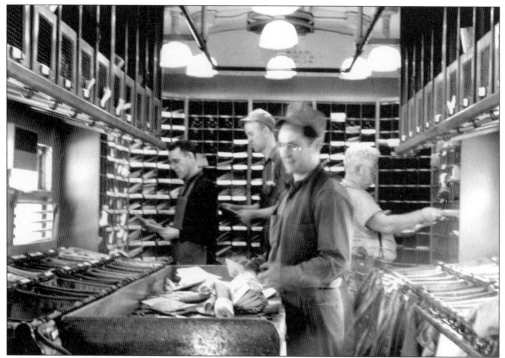

The railroad mail car, which stood alongside the Delaware, Lackawanna and Western station, served as the sorting room for all incoming and outgoing mail. This photograph, taken in the 1930s, shows chief clerk and Wharton resident James Eustice (far right) and others hard at work.

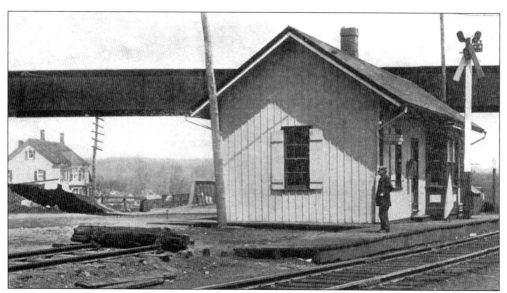

Shown in 1935, the railroad station at Main and Washington Streets was completed in 1876. It connected with other main lines over the hill and was the center of the iron district. The building was later moved to 12 East Dewey Avenue, where it was used as a private garage for years. It was donated to the Wharton Historical Society and is in the process of renovation.

Built c. 1905, the Wharton and Northern Railroad Building stood atop the hill north of Main Street and Washington Street, overlooking the entire elevated Wharton railway system. It served as a telegraph and ticket office and provided transportation for local commuters and students traveling by rail to Lake Denmark and Picatinny Arsenal, as well as travel to the furnaces. The pine forest surrounding the building and extending down Pine Street along the trestle banks was known as the Pine Grove section, or the Pinewoods. During the summer, Gypsies congregated in the groves to hold picnics and small fairs and to trade horses and tell fortunes.

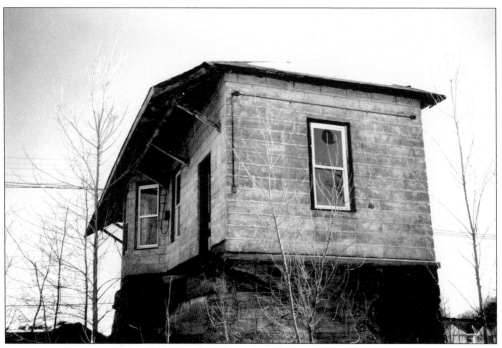

A historical landmark, the Wharton and Northern Railroad Building was torn down in 2000.

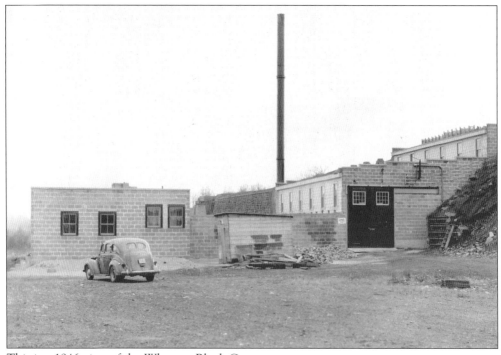

This is a 1946 view of the Wharton Block Company.

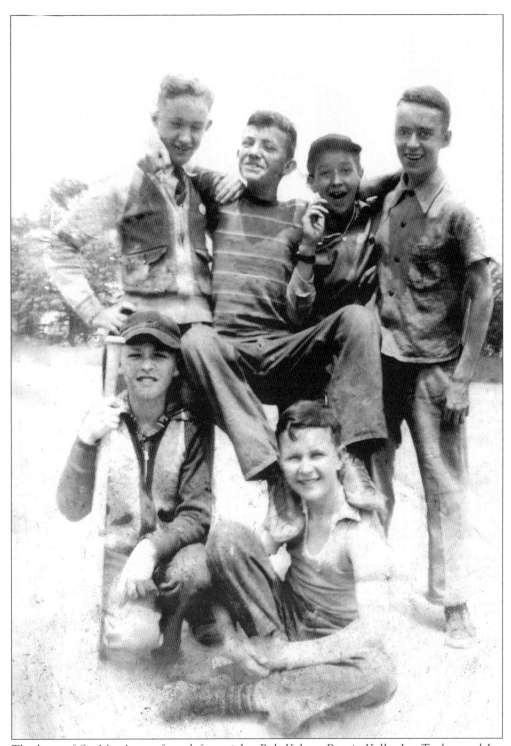

The boys of St. Mary's are, from left to right, Bob Kehoe, Bernie Kelly, Joe Taylor, and Joe Sullivan. Seated are Bob Murray (left) and Bill Keller. This photograph dates from the late 1930s or early 1940s.

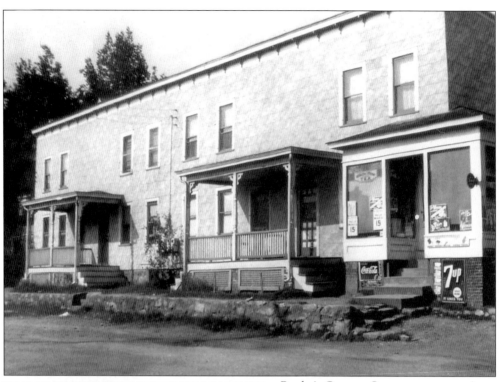

Rocky's Grocery Store was everyone's favorite spot. Andrew Rodkewitz began business at 9 South Main Street in 1924, before moving to the present address at 43 Roberts Street (which was built between 1909 and 1916) next to the Wharton High School. An original mom-and-pop store, Rocky's was famous (and still is) for selling his Cornish meat pies, called pasties. Everyone in town tried to copy the recipe. Rodkewitz's son Julius (pictured *c.* the 1930s with mother Anna and father Andrew) has run the business ever since his parents retired. Today, a third generation of the Rodkewitz family carries on the tradition. It is the oldest of Wharton establishments still standing and remains a very active operation.

Old iron and wood girder bridges (such as this one, crossing the Rockaway River by the dam on North Main Street) and a similar bridge that crossed the river on West Central Avenue were eventually replaced with more modern concrete crossings.

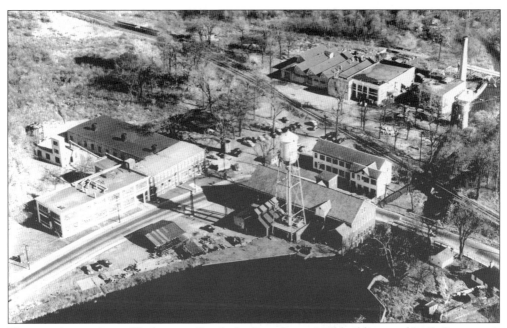

This aerial view shows Washington Pond, the Ross Street Mill building, and L. E. Carpenter's Vinyl Wall and Furniture Covering Plant along North Main Street c. the 1940s. The mill and the plant were steady employers of Wharton residents. The buildings still stand today and are owned by private enterprises.

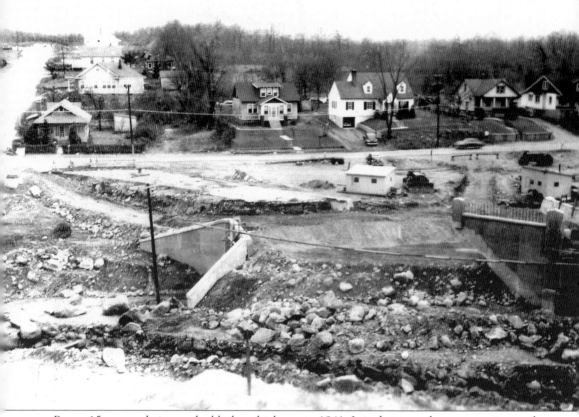

Route 15 was made into a double-lane highway in 1941. It is shown under construction at the bottom of Elizabeth Street in March 1943. The stream of water between the north and south lanes was once called the eastern branch of the Rockaway River, where, as old records show, Col. Jacob Ford of Morristown located the waterfalls of the Rockaway River at Mount Pleasant and proceeded to erect the first two forges in 1750, the beginning of Port Oram.

The fashionable Heslin House, formerly Hance House Saloon and Hotel, at 22 North Main Street, was established in 1850 by the Matthews family and sold to Charles Hance in 1865. It was known as the Port Oram Hotel c. 1887. Here on June 28, 1895, a mayor, six councilmen, an assessor, and a collector were elected to govern this new borough. These elected officials—store owners, a railroad superintendent, a schoolteacher, and mine superintendents—represented the leaders of the settlement. John P. Heslin purchased the building in the 1900s and passed the business down to daughter Kathleen, who ran the popular establishment for more than 50 years before selling the business to Joan Batson in the early 1980s. Today, it is a popular Mexican restaurant called La Fonda.

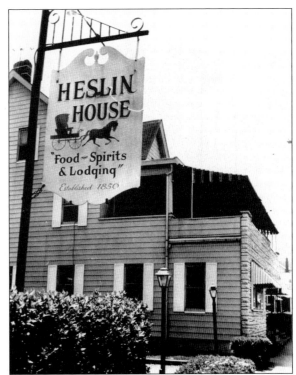

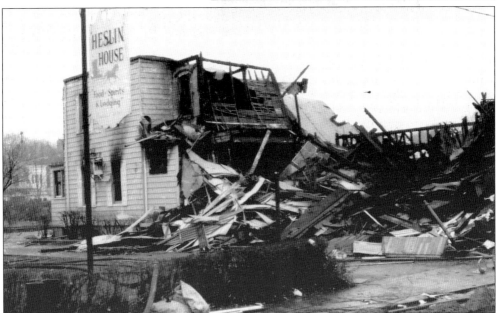

In the early morning hours of January 11, 1984, a gas leak explosion under Main Street's town center rocked the entire community. Original businesses such as the Heslin House and Hartley's Store, along with many new thriving establishments, were lost in the blast. Fortunately, due to the alertness of town locals and officials, all residents in the area were safely evacuated just minutes before the explosion. The landmark structure was rebuilt utilizing original pieces not destroyed in the blast.

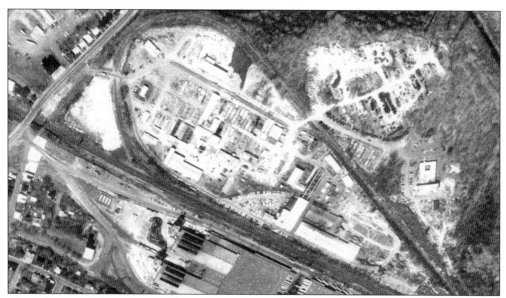

The Interpace Corporation purchased a 99-year lease from the borough for the property on which it built the Lock Joint Pipe Company in 1946. The company manufactured and produced pre-stressed concrete cylinder pipe for water and wastewater construction. For years residents could hear the whistle blow, announcing the ends of the two daily work shifts. In 1962, the Lock Joint Pipe Company merged with Gladden, McBean, and Company to become International Pipe and Ceramics Corporation, later known as Interpace. In 1968, they employed 410 local residents. Situated on North Main Street and east of the Thatcher Glass plant, the company closed its doors in 1980, and the borough sold the property in 1988 to RTC Pro. During this time, the county attempted to put the new county jail on the property but was unsuccessful thanks to borough council members. Shown here is an aerial view of Lock Joint taken in the 1970s. The smaller circular area to the upper right was "the pipe graveyard," a fun place to hang out as a kid. Today, the land houses three large businesses as well as Centennial Court Senior Housing.

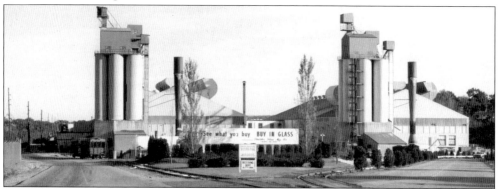

The Thatcher Glass Manufacturing Company was built on the grounds of the original Wharton Furnace. The furnace was later replaced by an insulation-manufacturing plant called Rock Wool in the 1940s and comically nicknamed by locals as "Itch 'n' Scratch" because of the irritating, prickly material it produced. Thatcher Glass was built in 1966. The most modern glass-container-manufacturing plant in the world for its time, the works manufactured and recycled glass for 20 years. Today, the facility houses many businesses and is known as the Wharton Interstate Commerce Center.

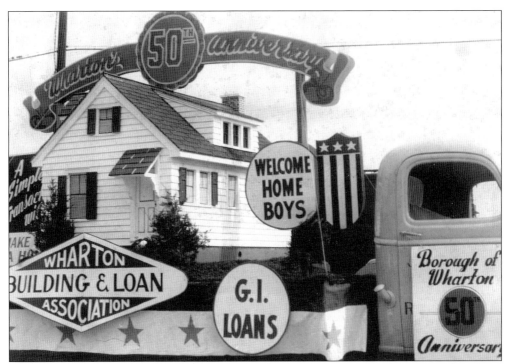

Wharton's 50th anniversary and World War II homecoming parade of 1946 marches down Main Street. Approximately 400 Wharton citizens served during the war, with 14 giving their lives for their country. Twelve of the boys who made the supreme sacrifice were from St. Mary's.

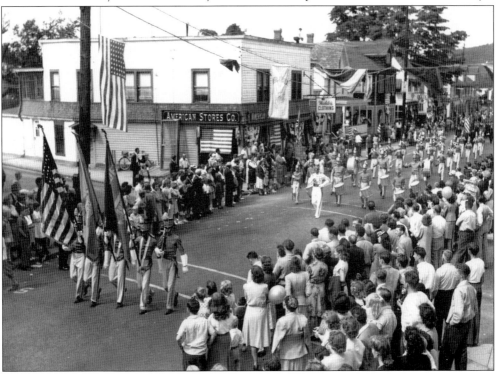

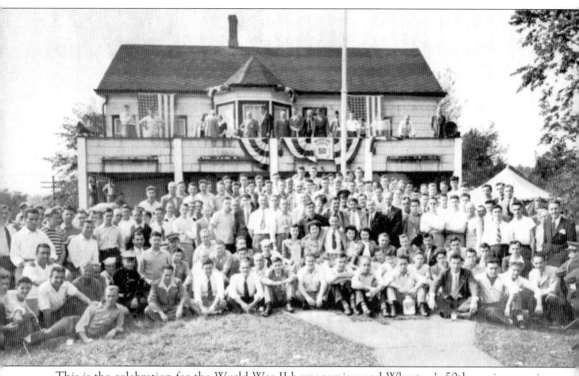

This is the celebration for the World War II homecoming and Wharton's 50th anniversary in 1946 at the American Legion Post No. 91.

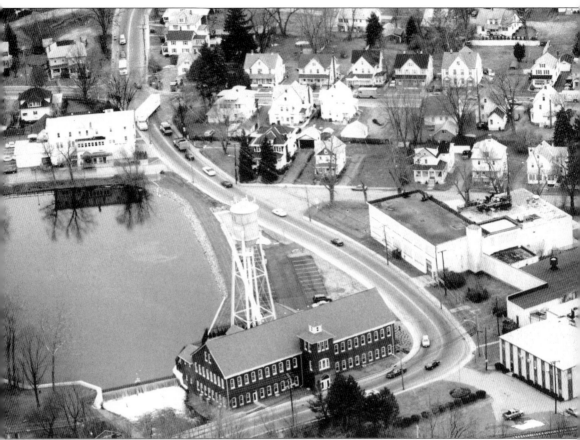

L. E. Carpenters and Company was established in 1943 and occupied the buildings (to the right) of the once flourishing silk mills. Before that, it was the site of the Washington Forge, which began operations as early as 1795. Until the end of World War II, Carpenters produced flameproof, mildew-proof, waterproof fabrics used by the armed forces for tents, gun covers, life jackets, and the like. Following the war, the fabrics were used for car interiors, ladies handbags, and the shoe industries. In 1956, it concentrated on manufacturing canvas and vinyl-coated fabric for wall, floor, and furniture coverings and sold under the brand names of Victrex (whose emblem was painted on the water tower for years), Vicrwall, and Victrex T. By the 1970s, it still employed nearly 200 Wharton residents.

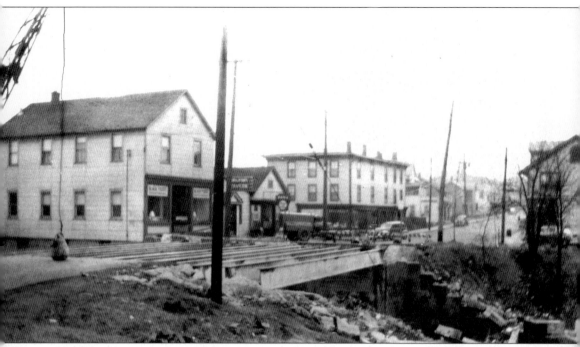

The Canal Bridge, on North Main Street, is dismantled, and the now dried Morris Canal beds will be filled in and forgotten.

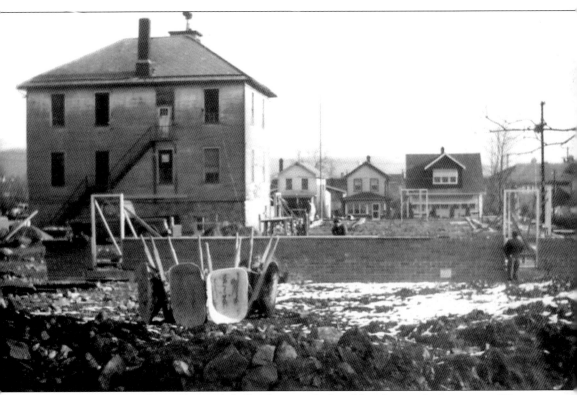

Shown is the dismantling of borough hall—down with the old and up with the new on West Central Avenue.

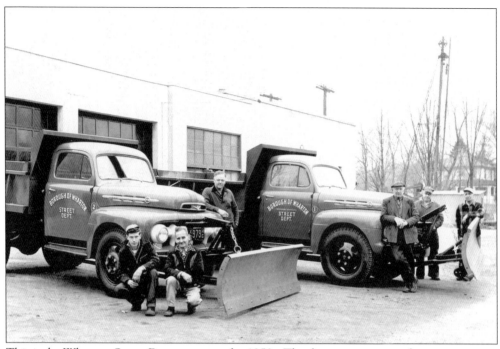

This is the Wharton Street Department *c.* the 1950s. The department serves the community at its location on the far end of West Central Avenue at the public works garage.

At Huff Field, the horse's name is Lady, and her owner is "Uncle" Daniel Hourigan. Huff Field and Sin Pond are now a mall, which includes the post office and retail establishments. The white building to the left is Mill's Tavern, on North Main Street.

Wharton High School students take a break by the Old Potter School c. the mid-1940s.

This advertisement for the Sugar Bowl ran in the *Wharton Chronicle* on July 16, 1936. The Sugar Bowl was the place local teens and bobbysoxers went to hang out, grab a milkshake, and jitterbug to the Jukebox Hit Parade. The original building stood in the center of town on Main Street, and in the late 1940s, the new Sugar Bowl moved to Mill Street, where it remained a hot spot all through the 1950s. Another favorite spot was Prandatos, at 12 South Main Street, established in 1910 and run by Silvio Prandato Sr. and his wife, Angelina. Their son Lewis took over operations in 1950 and assumed charge in 1954, after Silvio's retirement. What most teenagers of the day remember is the infamous Mello Roll, which was an ice-cream cone topped with orange sherbet.

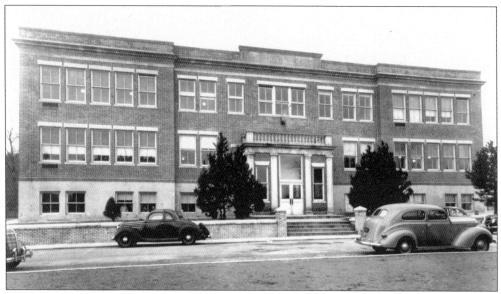

Wharton High School was built in 1922, enabling Wharton to provide a full four-year high school education. High school in Wharton ended in 1953, and students were rerouted to Morris Hills Regional High School in Rockaway. The school was rechristened Curtis School in 1954, when it became a middle school, in honor of William P. Curtis, the successor and former pupil of the esteemed Erastus Potter. Curtis' father was the Honorable William V. Curtis, mayor of Port Oram from 1895 to 1898. The use of the building as a school ended in 1974, when education was taken over by the MacKinnon Middle School. The building was sold on March 4, 1977, and now houses several businesses. The Harvey Mine was originally located in the rear of the building and into the hill.

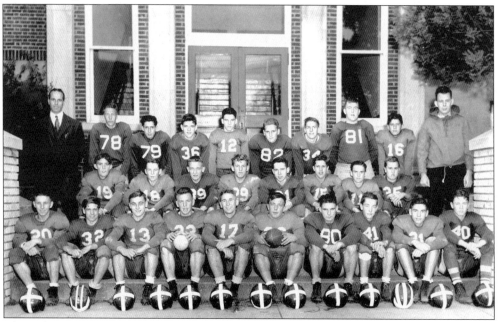

The Wharton Hornets, the Wharton High School football team, was coached by Joseph Romano in 1946.

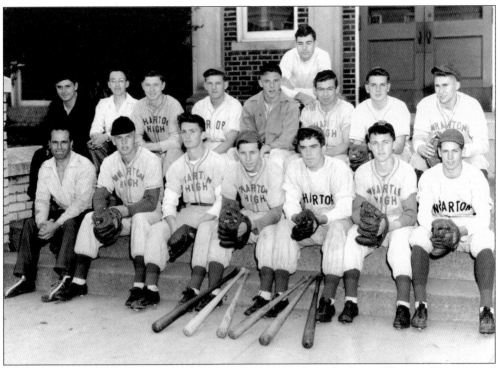

The Wharton High School baseball team in 1946 was also called the Wharton Hornets and coached by Joseph Romano.

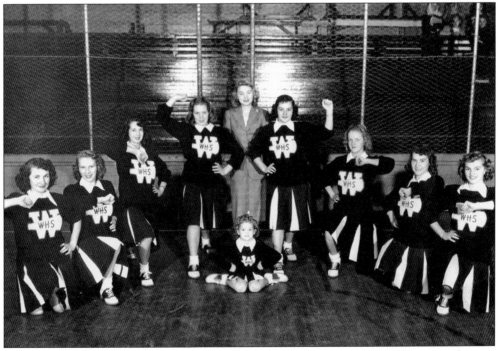

Pictured is the Wharton High School 1949–1950 cheerleading squad, with coach Florence "Dot" Ringel-Stephens.

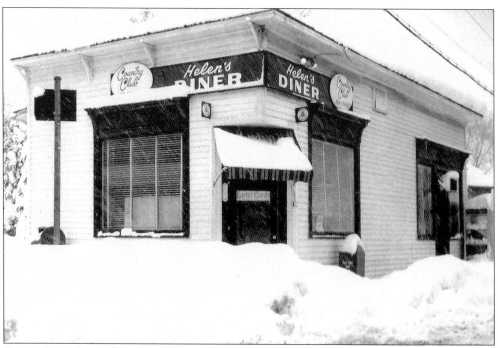

Originally established in the early 1900s as Wright's Corner Store on the corner of North Main Street and East Dewey Avenue in the Luxemburg section, Helen's Diner was a popular gathering spot for mill workers and teens in the early 1950s and early 1960s. The corner restaurant would later be purchased and renamed Dora's Diner before becoming Shep's Corner Deli in the 1970s. The building was torn down in the 1990s to become part of the ever expanding intersection.

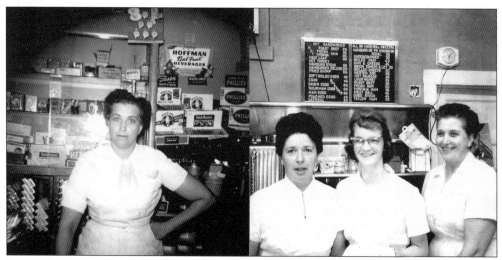

Pictured are owner Helen Dunning and coworkers Helen, Sharon, and Grace in the early 1960s.

Room is being made for the new National Union Bank at 20 North Main Street in 1958. The original branch office was at 25 North Main Street, and larger quarters were needed due to the tremendous response of residents and growing businesses.

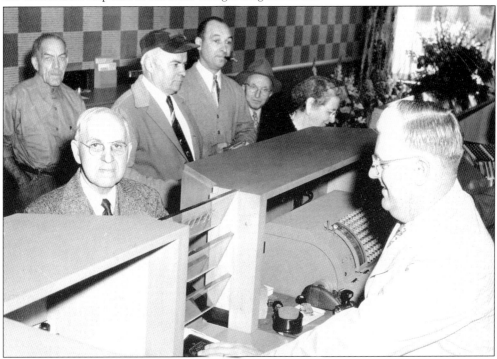

Teller Richard Rowe opens the line for his first customer, Louis Concialdi. Affectionately known as "Mr. Wharton," "Uncle Louis," and "Man of the Year," Concialdi served the community as Wharton's town pharmacist for more than 50 years (1918–1970). In the tradition of his predecessors, a Mr. Rosevear and a Mr. Wanamaker, he is remembered for his numerous kind deeds and willingness to help those in need.

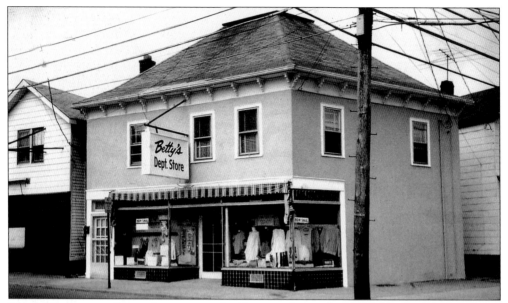

Betty's Department Store, the two-story building on the southwest corner of Main Street and West Central Avenue, was originally the Hyman Freeman Store, and its basement served as Port Oram's first jail in 1895. It became McSulla's in the 1940s, after moving from the Fern Avenue location, and then changed hands to Betty's Department Store, which was run by Betty Nametko and her sister. For youngsters in the 1950s and early 1960s, it was quite an adventure to enter.

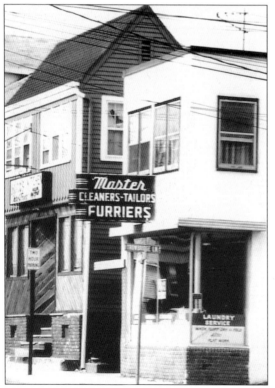

With a newly styled Art Moderne sign, the building at 19 North Main Street, on the curved corner of Trowbridge Lane, was home to Master's Cleaners until the 1970s. Farther down the road was Nazarro Cleaners, at 31 South Main Street. Established in 1912 (some sources state 1917), the business was run by Frank Nazarro, who passed it along to son Alfred. Alfred continued the family tradition into the 1990s. Though retired, Frank Nazarro was known to still stop in and do some occasional tailoring, always on the original machine he purchased in 1917.

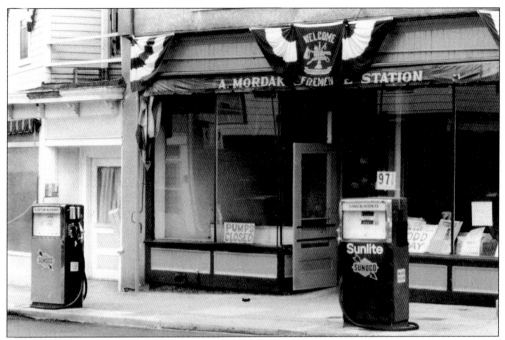

Mordak's is a borough landmark. Anna and Andrew Mordak pumped gas at their Main Street curbside filling station from 1937 until their retirement 48 years later. Sandwiched between a confectionary store and a butcher shop, the small storefront station served locals daily, and a toot from any passerby's car horn always prompted an immediate wave from the Mordaks. Though later zoning laws prohibited the dispensing of gasoline from curbside, a grandfather clause allowed the Mordaks to continue their operation until their retirement. The last of its kind, the pumps and tanks were removed on July 2, 1985.

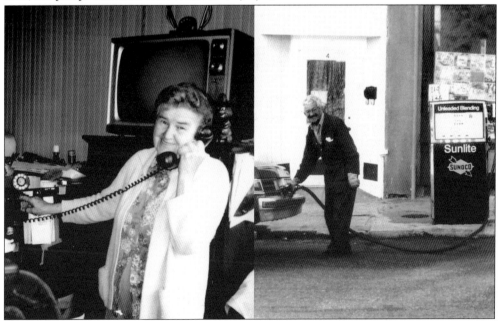

Annie takes care of business while Andy fills the tank.

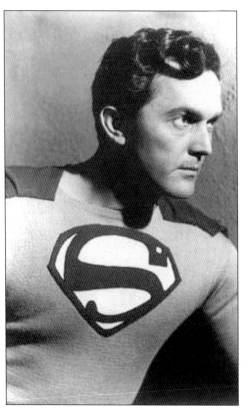

Kirk Allyn, the son of a Hungarian immigrant and Hollywood's first on-screen Superman, was born Jon Fego Jr. on October 8, 1910, in the rural furnace community of Oxford. His father settled his family in Wharton on West Central Avenue, where he worked as a carpenter. Jon attended Potter School before moving to New York City in 1927 to attend Columbia University and to major in journalism. He starred in vaudeville and Broadway, where he attracted the attention of Vitaphone and Columbia Pictures in Hollywood. Kirk played the Man of Steel in the Superman movie serials from 1948 through 1950 and appeared in film classics such as *The Time of Their Lives* (1946), *Little Miss Broadway* (1947), *The Three Musketeers* (1948), and as Lois Lane's dad in *Superman* (1978). Kirk often professed his love for his hometown of Wharton and was a frequent guest of the annual Canal Day, held every August. He died of natural causes on March 14, 1999, in his home in Woodlands, Texas.

Jon Fego Jr. is shown when he was still young Kirk Allyn. The photograph was taken *c.* 1919 at Potter School.

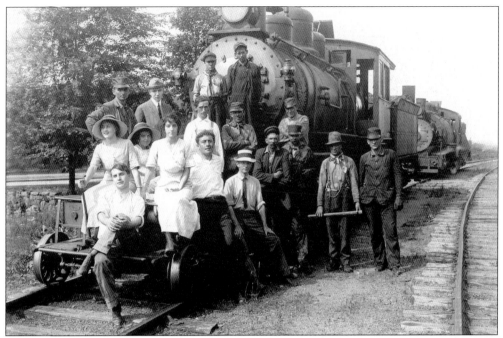

The Kalem Moving Picture Company is shown on location in Wharton for *The Engineer's Daughter* and *Peril of the Plains* (both 1911). Local railroad workers were used as extras. From left to right are the following: (first row) actor Carlyle Blackwell; (second row) actress Alice Nielson, unidentified, actress Alice Joyce, Hal Clemens, unidentified director, Pete Stryker (Wharton mayor, 1917–1920), J. Stryker, William Clarence Rowe, and Bob Grant; (third row) Worth Schulitz, John Carberry, Steve Mills, "Fod" Allison, unidentified cameraman, George Meloskie, and an unidentified extra.

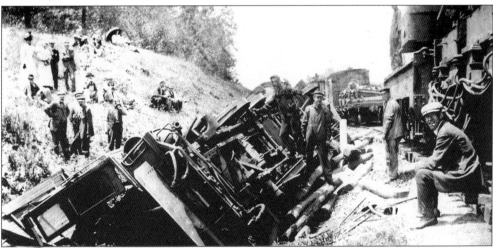

New Jersey was the original Hollywood. This spectacular train wreck in August 1914 was a reenactment for one of Pathe Moving Picture Company's numerous train robbery films. Taking place along the Wharton and Northern Railroads, the locomotive made double somersaults over a 100-foot embankment, thrilling more than 500 spectators. The engineer-stunt man of the locomotive jumped from the engine at the derail point with a dummy seated at the throttle when the big engine went to its doom.

Pop star Cyndi Lauper chose Wharton to film the music video for her song "Time After Time." The video was filmed in 1984 in front of Mordak's old gas station on Main Street and inside the Sweedy house, as well as other locations in the county. Lauper graciously donated the gold record she received for her album *She's So Unusual* to the Wharton Public Library, where it hangs today. She inscribed it in her humorous Lauper fashion, "Thanx, you couldn't have done it without me."

New Millennium Pictures' 2002 release of the cult horror flick *I'll Bury You Tomorrow* features Port Oram as its scenic small-town backdrop and center for its terrifying storyline. Pictured are Bill Corry and Katherine O'Sullivan in the starring roles. (Courtesy Zealot Pictures.)

Jennifer Demby Horton is another of Wharton's local celebrities. She was a winner from the U.S. Women's Handball Team of the Summer Olympics of 1996. Born and raised in Wharton, she lived on Lafayette Street, where her parents still reside today. (Courtesy Wharton Borough Hall.)

St. Mary's Roman Catholic Church is located at the end of South Main Street in the Marysville section. It was originally established in 1845–1846 by its strong supporting Irish community. The new church, which stands today and remains as Wharton's oldest church, was rebuilt by 1873 at an estimated cost of $50,000. The Victorian Gothic structure was constructed of local stone and designed by architect Jeremiah O'Rourke of Newark. The first frame schoolhouse was built in 1868, and the present-day St. Mary's parochial school was built in 1954.

This dance card was for the 1895 Memorial Day Dance held by St. Mary's. A dance card was the easiest method for a young lady to plan her social activities for the evening by scheduling each dance with a local boy (or potential suitor) of her choosing.

ST. MARY'S

C. Y. M. I. S.

MEMORIAL DAY, 1895.

The original St. John's United Methodist Episcopal Church, on the corner of Mount Pleasant Avenue and Church Street, was a simple frame chapel built in 1868 by the Mount Pleasant Mining Company to serve the religious needs of its Cornish mining population. With the influx of English, Irish, Polish, Slavic, and Hungarian immigrants moving into town for work during Port Oram's boom years, churches for each denomination were erected in the sections of town where each group took up residency among themselves.

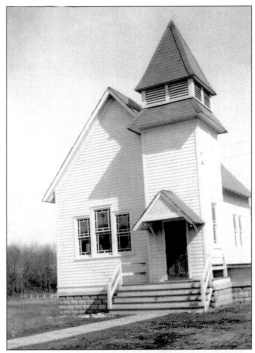

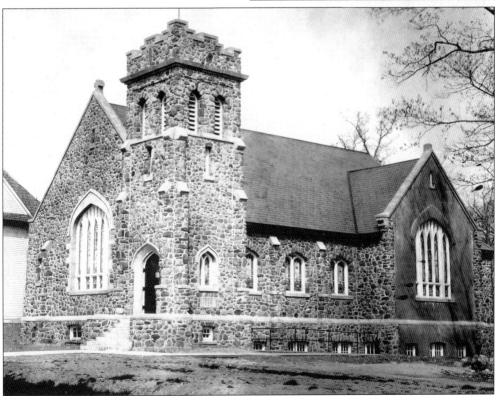

The new and larger St. John's Church, with its Gothic Revival stone edifice, was built in 1928. The church's parking lot was the site of the original St. John's, which was demolished in 1927.

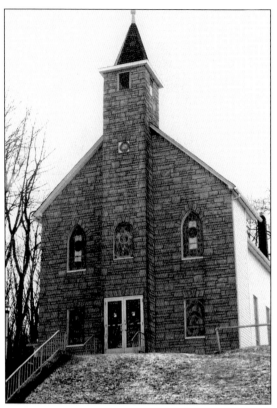

The Hungarian Presbyterian Church was established in 1904 in response to the spiritual needs of the growing Hungarian mining community and their families migrating to Wharton. After expressing a need to worship in their native language, the Hungarian community, with the assistance of St. John's Church, Luxemburg Presbyterian Church, Robert Oram, and private donations, erected the church on a piece of land on Roberts Street that was donated by Joseph Wharton.

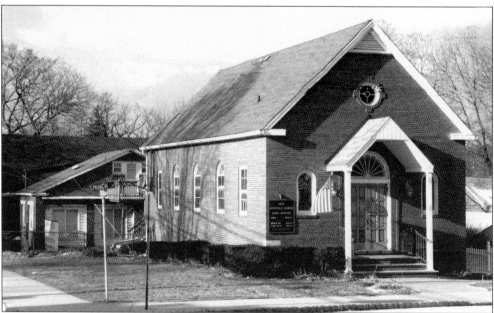

The Apostolic Church, on Church Street and East Central Avenue, was established in 1945 by resident John Kiss. The brick house on the corner also belonged to the congregation as the parsonage. The true desire of this new church and Kiss' mission was to "enlighten the Word of Christ, no matter what one's faith. All are welcome at any time to rest, think and pray."

Formed in 1900 by a small group of
Presbyterians who met for services in the
house at 3 West Dewey Avenue, the
Luxemburg United Presbyterian Church, on
North Main Street in the Luxemburg area
of Port Oram, commenced on November
14, 1901. Nicknamed "the little church on
the corner," it became a place to go for
Cornish, Welsh, and English migrants and
their families. Known for its extensive
youth programs, it was, and remains today,
very popular in the Christian endeavors of
a Young People's Society.

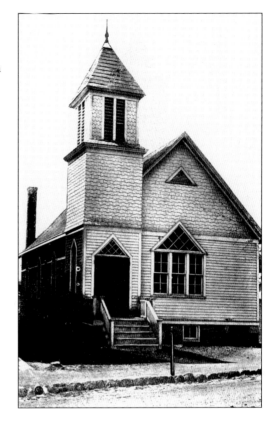

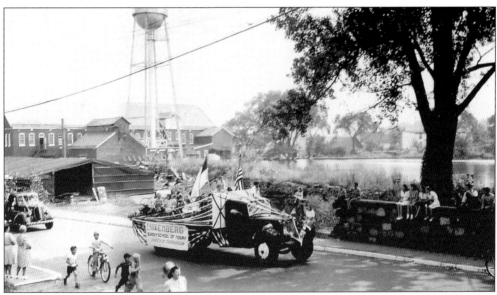

A Wharton parade in the 1950s proudly showcases "the Sunday School of Today" float from
"the Church of Tomorrow"—Luxemburg United Presbyterian. The high stone wall along the
Washington Pond always guaranteed the best viewing spot.

Santa arrives for the Christmas celebration in Memorial Park in December 1952.

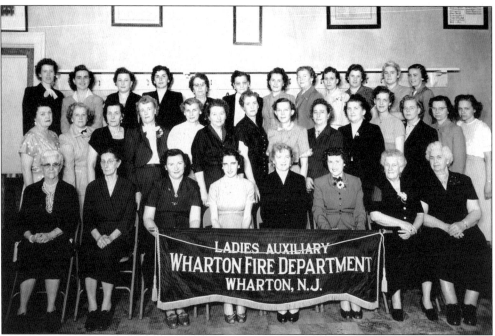

The ladies' auxiliary of Wharton Fire Department, pictured in 1954, was the most active supporter of the Wharton Fire Department. Formed on July 21, 1929, the auxiliary hosted dinners, charity bazaars, carnivals, and social activities. Made up of noble and caring women of Wharton, the auxiliary also supplied aid to disabled firemen and families of firemen who died in the line of duty and acted as emergency suppliers and aides on a moment's notice.

Wharton's native daughter, the beloved Marie V. Duffy, grew up on St. Mary's Street and graduated from Potter and Wharton High Schools. She became a teacher and eventually principal of Potter School. She retired shortly after the community built the Marie V. Duffy Elementary School, on East Central Avenue, in her honor and presented her with a loving tribute in the new school's auditorium on October 20, 1963. The dedication ceremony is pictured below.

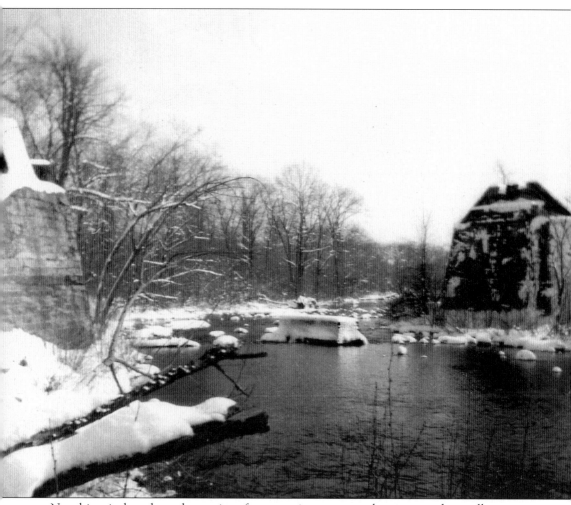

Now historical markers, these ruins of two massive concrete abutments and a smaller concrete pier hugging the Rockaway River just east of West Central Avenue are all that remain of the once elevated railways used in Wharton's early day mining transports. This photograph was shot in February 1957 and shows that the area remains surprisingly identical today.

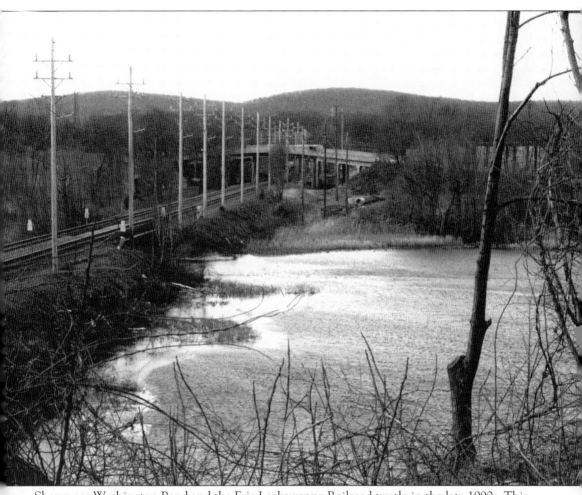

Shown are Washington Pond and the Erie Lackawanna Railroad trestle in the late 1990s. This view was taken just south of the West Dewey Avenue overpass and before condominiums dug their path through the natural marshlands.

The Wharton Afghan was designed in 1996 by Charlotte Kelly, a member of the Wharton Celebration Committee.

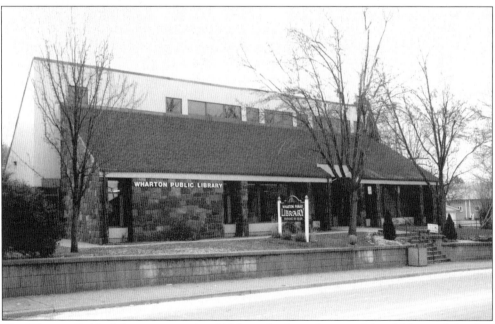

The Wharton Public Library, pictured in 2004, was built on the site of the old Potter School in the early 1970s. The library functions as a full-service learning institution. Note that the old concrete retaining wall on Main Street has remained intact.

The Wharton Clock stands tall and on time on the corner of Main Street and East Central Avenue.

Ye Olde Wine & Cheese Shoppe and Wharton Liquors have been staple businesses for years. They are housed in the original building of John Hill and Company (1860); Oram, Hance, and Company (1861); and R. F. Oram and Company (1892). The original storefront faced the parking lot (to the right), giving easy access to the stores' loading docks and the Morris Canal, which ran parallel to the building.

The Wharton Fire Department celebrates its 100th anniversary in 2004. Fire chiefs, preceded by their dates of service, are as follows: 1904 Charles Hance, 1905–1908 Robert F. Oram, 1909 Harry Hance, 1910–1911 William H. Ball, 1912–1913 Edward J. Hicks, 1914 William P. Curtis, 1915–1916 Edgar D. Hopler, 1917 Dan J. Kettrick, 1918 William Webber, 1919 John C. Hocking, 1920 John H. Bennett, 1921 J. Harry Williams, 1922 James H. Stryker, 1923 G. Alvin Dorman, 1924 Thomas J. Spargo, 1925 James A. Dowson, 1926 James A. Flynn, 1927 Ellsworth Post, 1928 Worth Shultis, 1929 William Skewes, 1930 Rudolph J. Meilele, 1931 Steven Lovas, 1932 John Waters, 1933 Richard J. Rowe, 1934 Stanley Trezona, 1935 Clarence Hocking, 1936 Nicolas Stefanic, 1937 Francis Waters, 1938 Arthur Somerville, 1939 Chester F. Ritzer, 1940 Carl W. Ritzer, 1941 William M. Rowe, 1942 T. James Trezona, 1943 J. Elwin Williams, 1944 Frank Ritzer, 1945 Kenneth Bragg, 1946 Lloyd W. Matthews, 1947 Frederick Grandin, 1948 Andrew Risko, 1949 Nicolas Garanyi, 1950 Charles E. Dabb, 1951 Emil Saloky, 1952 Martin Trengove, 1953 Abraham Hocking, 1954 Andrew Proctor, 1955 William F. Ritzer, 1956 Harold Martenis, 1957 Paul Doboney, 1958 John W. Agansky, 1959 Matthew Wicha, 1960 Harry Simon, 1961 Alexander Nechay, 1962 Stephen B. Szoke, 1963 Eugene P. May, 1964 William R. Humphreys, 1965 Frank E. Wolfinger, 1966 William F. Williams, 1967 Alton L. Lattig, 1968 Harry R. Shupe, 1969 Stephen J. George, 1970 Stanley House, 1971 William C. Shupe, 1972 Robert T. Williams, 1973 Gordon K. Winch, 1974 James A. Rhead, 1975 Leonard A. Williams, 1976 Anthony A. Rega, 1977 Thomas W. Watters, 1978 William G. Skewes Jr., 1979 James W. Rice, 1980 William C. Shupe, 1981 John Sheplak, 1982 Joseph Harder Jr., 1983 Thomas W. Watters, 1984 Robert O'Malley, 1985 Michael Loury, 1986 Cornelius Griffin, 1987 Michael Sabo, 1988 Richard Malone, 1989 Ronald Krasnick, 1990 Kevin B. Finnegan, 1991 Joseph Harder Jr., 1992 Constantine Yellinski, 1993 Daniel Brice, 1994 John Craven, 1995 Michael Marks, 1996 Gene Minell, 1997 John R. Schomp, 1998 Doug Kish, 1999 Mark Williams, 2000 Chris Elio, 2001 Dean Bradley, 2002 Dennis Sanderson, 2003 Kyle M. Dorr, and 2004 Edward J. Nunn.

Under the borough of Wharton emblem are listed the Wharton mayors, preceded by their dates of service: 1895–1898 William V. Curtis, 1899–1900 H. W. Kice, 1901–1902 Michael Mulligan, 1903–1906 J. H. Williams, 1907–1908 S. S. Smith, 1909–1912 R. F. Oram, 1913–1914 U.G. Davenport, 1915–1916 J. R. Spargo, 1917–1920 Peter Stryker, 1921–1928 E. W. Rosevear, 1929–1932 J. H. Williams, 1933–1934 Frank Fishbourne, 1935–1936 H. O. Winch, 1937–1940 Frank J. Porter, 1941–1942 John L. Lynch, 1943–1944 Wilfred Keats, 1945–1946 John L. Lynch, 1947–1950 Hugh A. Force, 1951–1952 Frederick Grandin, 1953–1956 Corriell Fancher, 1957–1960 Robert A. Anderson, 1961–1962 Arthur R. Collins, 1963–1964 W. R. Dunkelberger, 1965–1966 William McMyne, 1967–1970 Walter Krich, 1971–1974 Martell Jones, 1975–1978 T. Grahowski, 1979–1982 H. J. Marks, 1983–1990 T. Bernie, 1991–2000 Harry R. Shupe, 2000–2001 L. J. Finnegan Jr., and 2001–present William J. Chegwidden.

Preceded by their dates of service, the presidents of the Wharton First Aid and Rescue Squad, formed in 1934 within the fire department and officially recognized in 1951, are as follows: 1951 Jack Kernick, 1952 Ken Bragg, 1953 Jack Keeshan, 1954 Vincent Bishop, 1955 Daniel Bronock, 1956 Ray Foster, 1957 Frank Novak, 1958 Robert Henderson, 1959 Edward Bolster, 1960 Thomas Chiappa, 1961 Ralph Magliaccio, 1962 Charles Chudley, 1963 Robert Sherwood, 1964 John Fitzpatrick, 1965 Walter Weiss, 1966 Paul Konyak, 1967 Melvin Chudley, 1968 Keith Allison, 1969 George Root, 1970 Jack Cooper, 1971 William Wassmer, 1972 John R. Newkirk, 1973 Glen Gaylord, 1974 Manfred Shulz, 1975 Robert Sim, 1976 John Fisher, 1977 Andrew Dodson, 1978 Tom Keffer, 1979 Frank Novak, 1980 Manfred Shulz, 1981 Robert Sherwood, 1982 John R. Newkirk, 1983 Donald Sheath, 1984 John Yaciuk, 1985 Linda Darrow, 1986 Manfred Shulz, 1987 John Newkirk, 1988 Susan Best, 1989 Sandy Howarth, 1990 Jackie Yacuik, 1991 Sandy Howarth, 1992 Manfred Shulz, 1993 Steve Mitchell, 1994 Sandy Howarth, 1995 Jackie Yacuik, 1996 Steve Mitchell, 1997 Kelly Wells Wunder, 1998 Sandy Howarth, 1999 Jackie Yacuik, 2000 Rodney Howarth, 2001 John Wells, 2002 Steve Mitchell, 2003 Bob Marinus Door, and 2004 Carmine Franco.

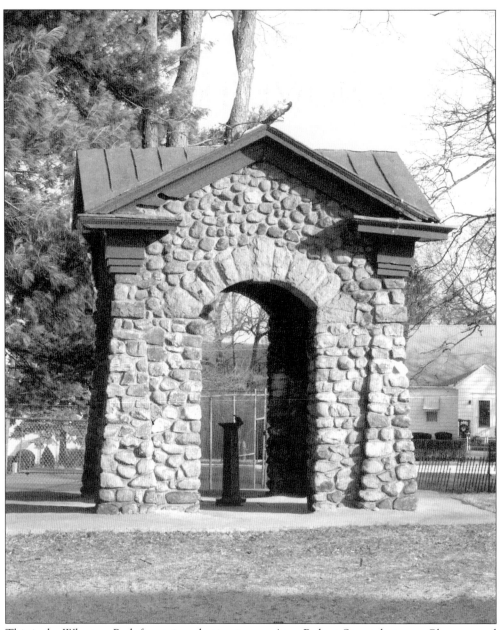

This is the Wharton Park fountain, a lasting image. Atop Robert Street, between Clarence and Sterling Streets, sits this historic cobblestone fountain landmark resting on a grassy knoll of the 28 acres of Joseph Wharton Park. The land was donated by Wharton as "a Christmas gift" to the town in December 1908, shortly before his death on January 11, 1909. Robert F. Oram Jr. donated this stone shelter structure in memory of his father, R. F. Oram Sr., in 1911. Anyone who was a child in Wharton fondly remembers this special place.

ACKNOWLEDGMENTS

A very special mention goes to Martin and Edith Trengrove, Jack Bermingham, Nancy Kaminetsky at the Wharton Public Library, the Wharton Historical Society, George and Sandra Schaller, Wharton Borough Hall, John Agansky, Chief Edward J. Nunn of the Wharton Fire Department, the Picatinny Museum, Julius Rodkewitz, Myrtle Danielson, Doris Bone, and Irene Whitham.

Exceptional thanks go to the Kelly family, the Rowe family, Rose Bencel, Pat Orielo, Tom Burns, and the endless list of Wharton neighbors, families, friends, and businesses who contributed so many facts, bits of information, and fond memories by simply saying, "I remember when. . . ."

Finally, here is a personal note of thanks to my oldest and dearest friends in the world, Larry Kimble and Nancy Kimble-Wheatley, with whom growing up in Wharton was an adventure every day.

—Alan Rowe Kelly

BIBLIOGRAPHY

Hance, Rev. Edward. "History of Early Wharton." Oration at the dedication of the new Wharton Park, July 4, 1911.

Hansen, Kenneth R. *Port Oram—c. 1882—A New Jersey Iron Town*. N.p., n.d.

Hill, Hon. John. *Biographical and Genealogical History of Morris County New Jersey Volume II*. New York and Chicago: the Lewis Publishing Company, 1899.

Hill, Jean. "Wharton United Presbyterian Church: 1901–2001: One Hundred Years of Faith." Wharton.

Historical Records Survey Division of Professional and Service Projects Works Projects Administration Inventory of the Municipal Archives of New Jersey No. 14 Morris County Volume XXXVIII. Wharton: Historical Records Survey, Newark, 1939.

Morris County Heritage Commission, Morris County Board of Chosen Freeholders, Office of New Jersey Heritage, and Acroterian-Historic Preservations Consultants. *The New Jersey Historic Sites Inventory: Morris County Cultural Resources Survey: Wharton 1986–1987*.

Munsell, W. W. *History of Morris County, New Jersey*. New York: George MacNamara Press, 1882.

O'Neil, Neil. "Bit of Wharton Nostalgia—History of the Castner Deal." *Daily Advance*. Dover, New Jersey, *c*. 1970.

Owens, Patrick J. "Marking the 70th Anniversary of the 1926 Explosion Here." *Voice*. July 12, 1996.

Rudinsky, Paul J. *This is Wharton 1895–1970: 75th Anniversary*. Borough of Wharton.

Trengrove, Martin. *Directory of Historical Markers and Commentary: Borough of Wharton 1895–1995*. Wharton: Wharton Centennial Committee, June 1995.

Webb, James Augustus. *Biographical and Genealogical History of Morris County New Jersey Volume I*. New York and Chicago: the Lewis Publishing Company, 1899.